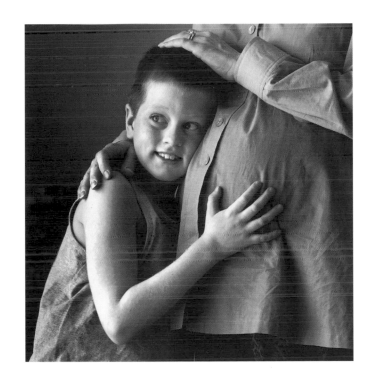

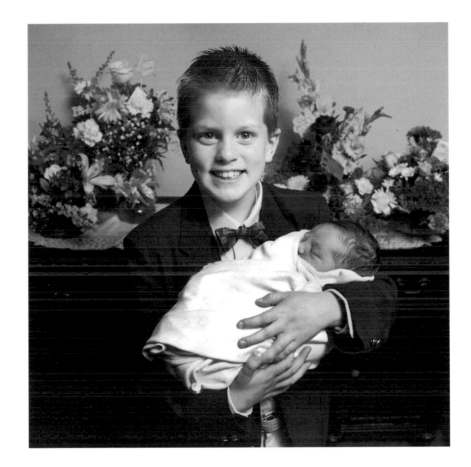

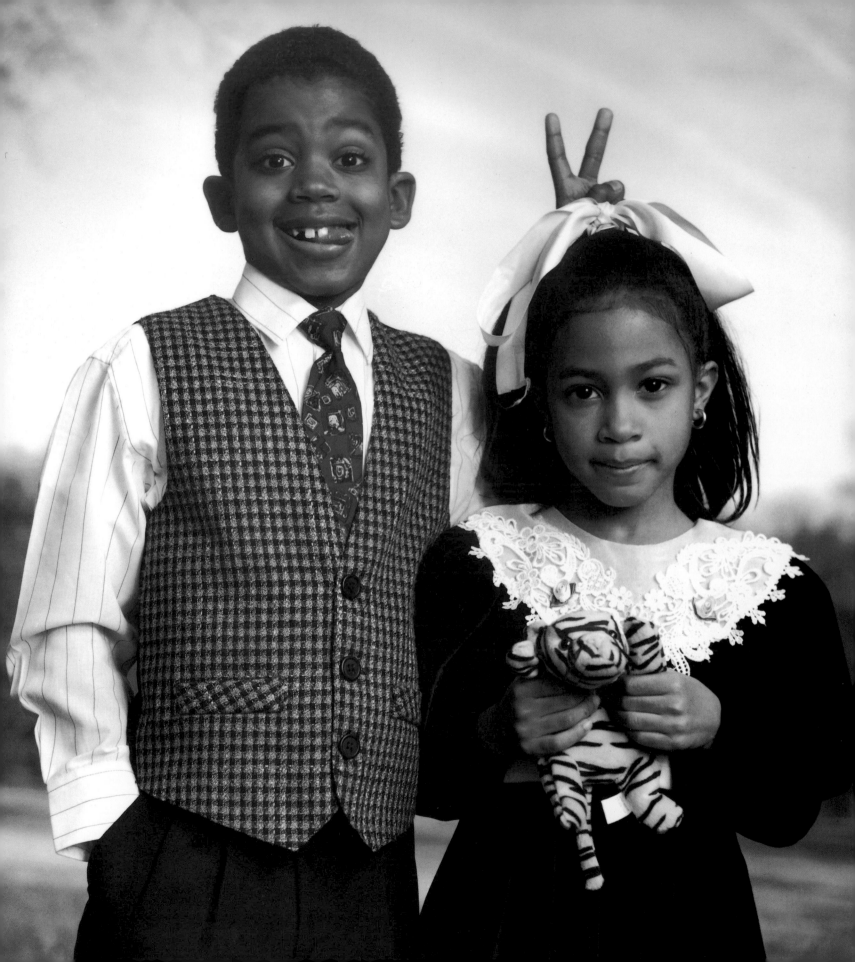

# SIBLINGS

## Nick Kelsh & Anna Quindlen

PENGUIN
STUDIO

PENGUIN STUDIO
Published by the Penguin Group
Penguin Putnam Inc., 375 Hudson Street,
New York, New York 10014, U.S.A.
Penguin Books Ltd, 27 Wrights Lane,
London W8 5TZ, England
Penguin Books Australia Ltd, Ringwood,
Victoria, Australia
Penguin Books Canada Ltd, 10 Alcorn Avenue,
Toronto, Ontario, Canada M4V 3B2
Penguin Books (N.Z.) Ltd, 182–190 Wairau Road,
Auckland 10, New Zealand
Penguin India, 210 Chiranjiv Tower, 43 Nehru Place,
New Delhi 11009, India

Penguin Books Ltd, Registered Offices:
Harmondsworth, Middlesex, England

First published in 1998 by Penguin Studio,
a member of Penguin Putnam Inc.

1 3 5 7 9 10 8 6 4 2

Photographs copyright © Nick Kelsh, 1998
Text copyright © Anna Quindlen, 1998
All rights reserved

Grateful acknowledgment is made for permission to reprint excerpts from
*Julius, The Baby of the World* by Kevin Henkes. Copyright © 1990 by Kevin Henkes.
By permission of Greenwillow Books, a division of William Morrow & Company, Inc.

ISBN 0–670–87882–0

CIP data available

Printed in the United States of America
Set in Centaur MT
Designed by Lisa Winward & Lauren Mann
at Kelsh Wilson *design inc.*

For Bruce, Eric and Joel, but mostly for Jill, who put up with us.

—*Nick Kelsh*

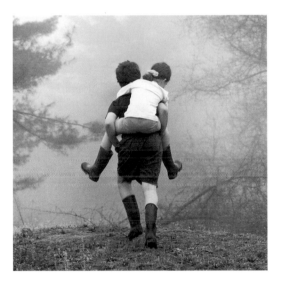

For Bob, Mike, Kevin and Theresa.

—*Anna Quindlen*

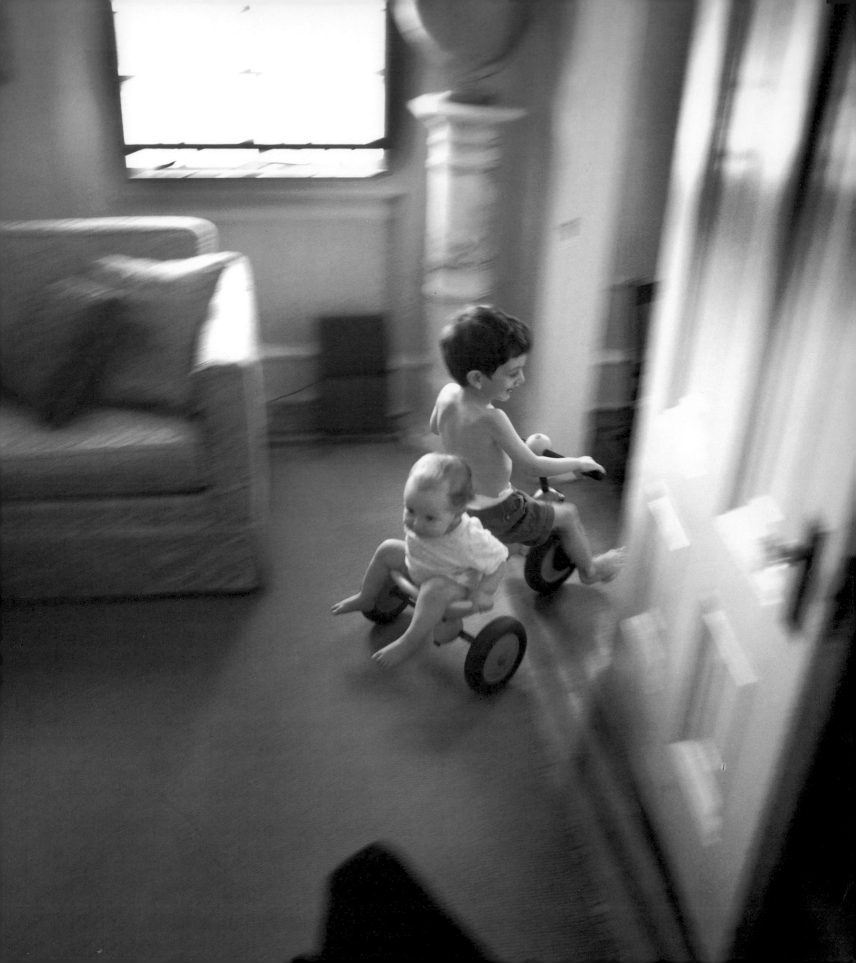

# Siblings

The most vivid emotion of my childhood, at least in memory,

is not the heavy sadness I felt as our dining room suite and our

disassembled beds went into the moving van. It is not the warm,

palpable joy of wandering the streets at Halloween with a full

trick-or-treat bag and my best friend Donna. It is not even

the love of my much-beloved mother, or the fear of my father's

infrequent fury. ❧ The most vivid emotion of my childhood,

the one I can evoke even now, is my hatred of my brother Bob.

Truth is, the word "hatred," simple and powerful as a punch to the gut, does not

even begin to cover what I remember feeling. What I remember back to when I

could barely walk and he barely stand. A virtual rainbow of negative emotions—

contempt, loathing, disdain—that is how I remember my life with my brother

from the time he improbably arrived, cradled in my mother's arms, when I was

little more than a year old. It's like remembering a wonderful meal or a remark-

able painting, remembering how much I hated Bob, then called by the diminutive

"Robbie." There is something so pure and uncompromising in the feeling, like the

taste of a lemon or the prick of a thorn. It's almost pleasurable, actually, to think

of it, in my today world, where I have learned to shave off the sharper edges

of experience, to be ambivalent, equivocal, to compromise. § I hated him.

Oh, how I hated him. § I can only tell this story because I now love

my brother as fiercely as I once loathed him. This is not because we are alike,

although we are to the extent that we are both gregarious and deeply inward in

some strange dichotomous way. I like to think Bob is the person I would have

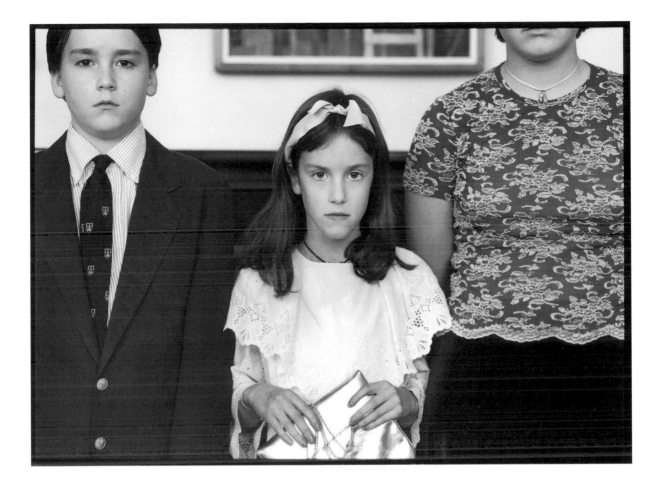

been had I come second, he first, although of course that would have changed

everything, for both of us. He is unpretentious, generous and good-hearted but

nobody's fool. He is smart but he does not show off; he feels no need to impress.

He is ironic and funny and mocking with just the right edge of kidding to it. He

runs a day care center and wears an earring. You would like him; everyone does. ॐ

A virtual
rainbow
of negative
emotions—

contempt,

loathing,

disdain—

that is how I

remember my life

with my brother.

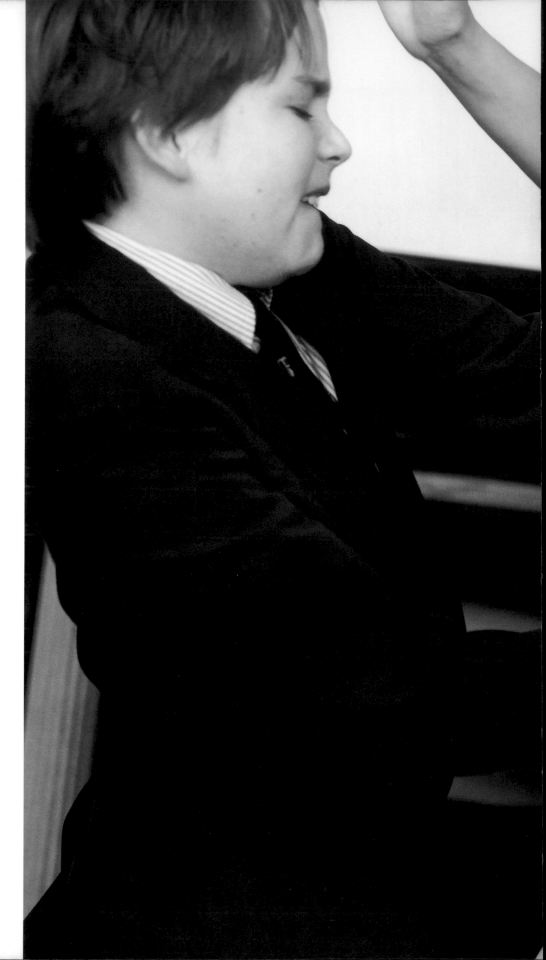

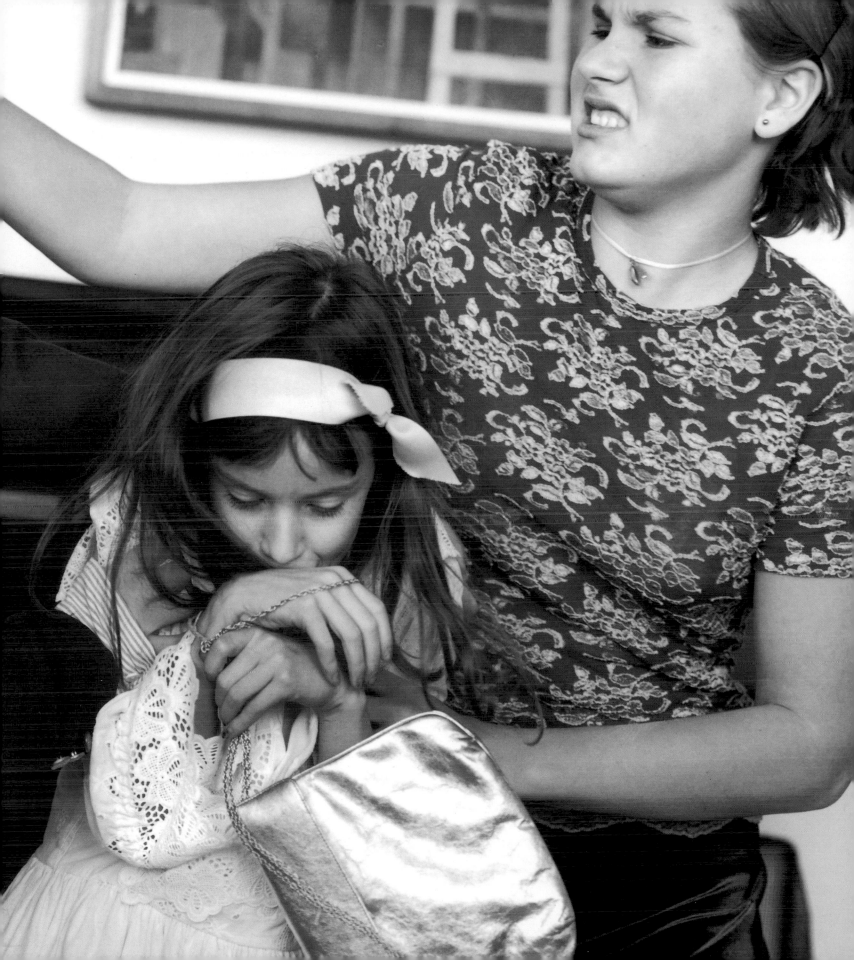

I have two other brothers, Mike and Kevin, with whom I have had relationships

different, in truth much less, than the one I have with Bob. There is often a kind

of domino theory to sibling relationships; our more powerful bond, for good

or ill, is with the one closest in age. Naturally, we all feel particularly close to

Theresa, who is the youngest and so will be treated by all of us, mostly covertly

now, like something of an incompetent the rest of her life, even though she is the

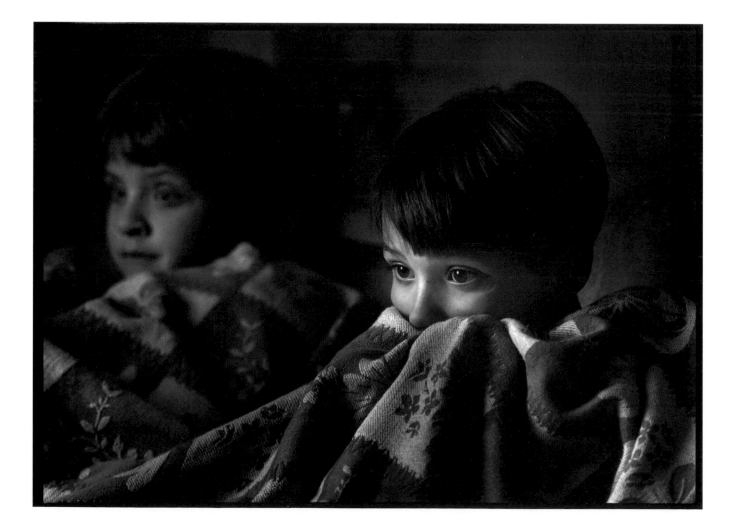

only one who has had the guts and the wherewithal to live all around the country and re-create her life every couple of years. ❧ But I have a special relationship with Bob by virtue of the fact that he is able to validate my history simply by existing. He is the only living witness to what childhood was like in our household at a particular moment. He knows what the kitchen looked like on Kenwood Road, how he mocked the boys who came to listen to the Beatles on the tinny stereo in the living room, why we moved to the big antebellum plantation house in West Virginia, the trouble we got into in cars and in the basement when our parents thought we were doing nothing, or being good, or something. He shared the rooms and the lifeline and especially the mother and father I had for many years. Which is why I hated him so in the beginning. ❧ I don't understand how people learn to live in the world if they haven't had siblings. Those readers who are only children must recoil from that sentence; I can only beg pardon, and the myopia of one who can never recall, until she'd graduated from college and rented a small one-bedroom at the tail end of the island of Manhattan, being alone in the house. Everything I learned about negotiation, territoriality, coexistence, dislike,

inbred differences and love despite knowledge I learned from these four: Bob, Mike, Kevin, Theresa. In some essential way, they were my universe, even more than my parents. ❧ For while we costume ourselves for our mothers and fathers, pretend to be what they want or strike a pose as that which they most abhor, we let down our guard for our siblings day after day, year after year, without thinking about it much.

We share with them real life. We've seen them naked, in every imaginable sense of that word. ❧ Sometimes, when I was in my twenties, my friends would report

meeting a man with whom they could be intimate, so intimate that they admitted him into the grimy details of daily existence. This was a man who could see you sick, watch you cry and hand you a tissue for your snotty nose, even share a bathroom. This was a man who might someday be a husband. ❧ Well, I've been that intimate with my husband, but I'd been that intimate and a million times more with my brothers and sister for many, many years. Sometimes, at college, in the dorms, people would complain about the lack of privacy, and I'd just laugh. I'd screamed as my brothers barged into the bathroom while I was in the tub. I'd surprised them on the living room couch when they were prone, in the dark, with

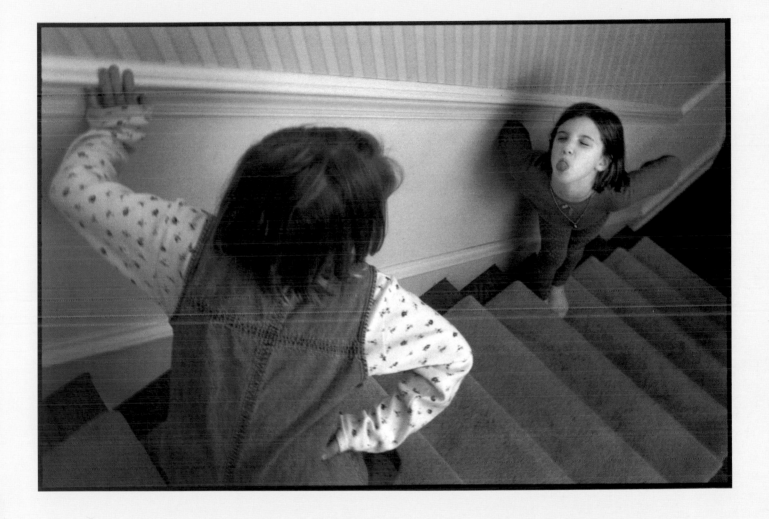

18
.

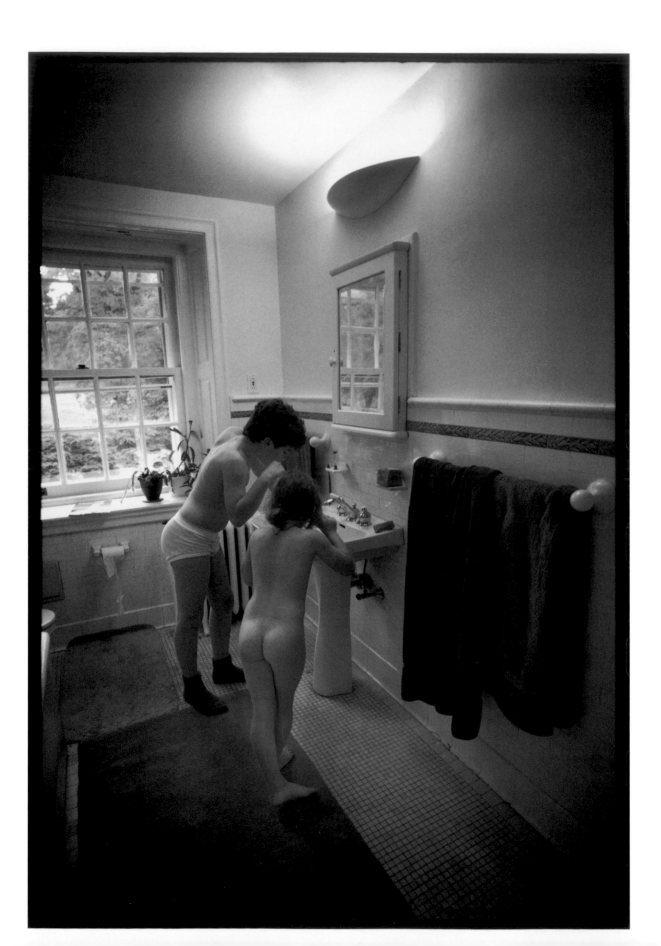

their girlfriends. I changed my sister's diapers. I made her school lunches. I told her which books to read, filled her in on menstruation and birth control. And she told me the things she could not tell our father. ❧ "Three to a bed," one of the two women who cleans our house said to me one day about her and her five sisters. The other woman who cleans alongside her is one of those sisters, and as I work I can hear them bickering, with a sound like an old engine running upstairs. I have never seen one without the other, as though they are Siamese twins. Lena says Lil used to hide her candy when she was a kid. Lil says if she didn't hide it it would all get eaten. In their seventies, they live in the same apartment building. "Oh, privacy," says Lena, as though it were sapphires, something nice she's heard good things about but will never have, nor particularly yearn for. ❧ "They're all you'll have someday," my mother used to say when we would bicker, fight, or strike one another, as we did with some frequency. I always thought there was something pathetic about the way she'd say that, as though our siblings would be the sad leftovers on the plate of life, scraps of fat, puddles of congealed gravy. But as I say it to my own three children now—and I do, I do, almost despite myself—I realize that she meant something quite different. And I

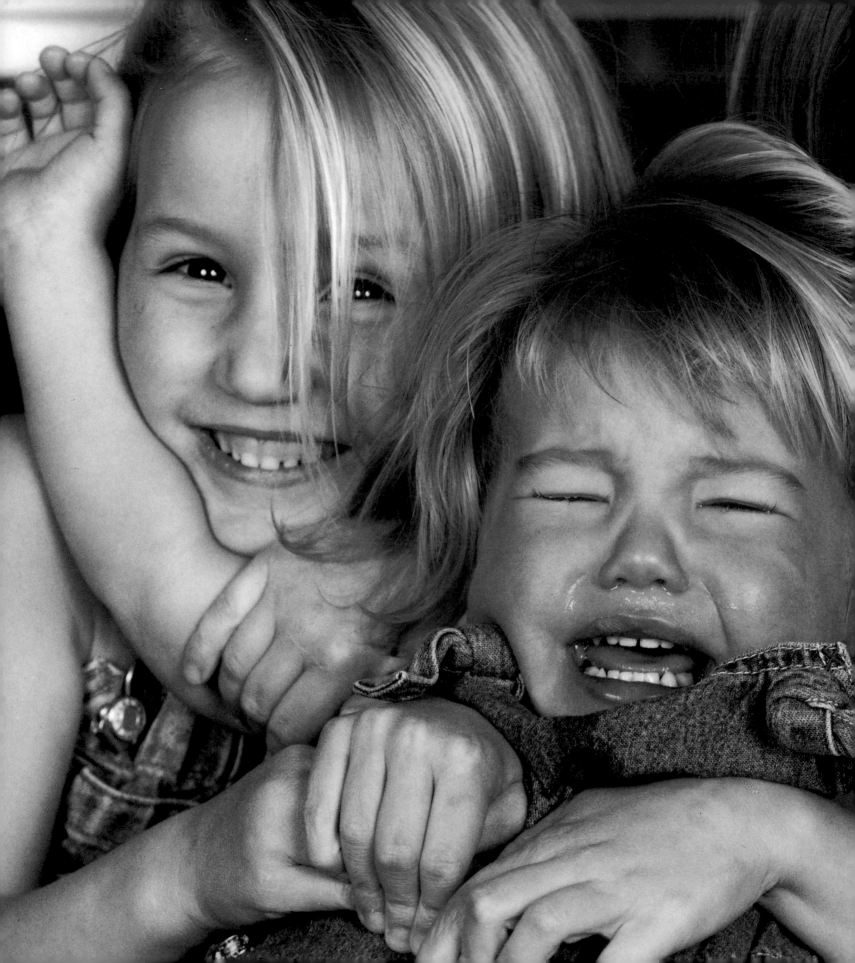

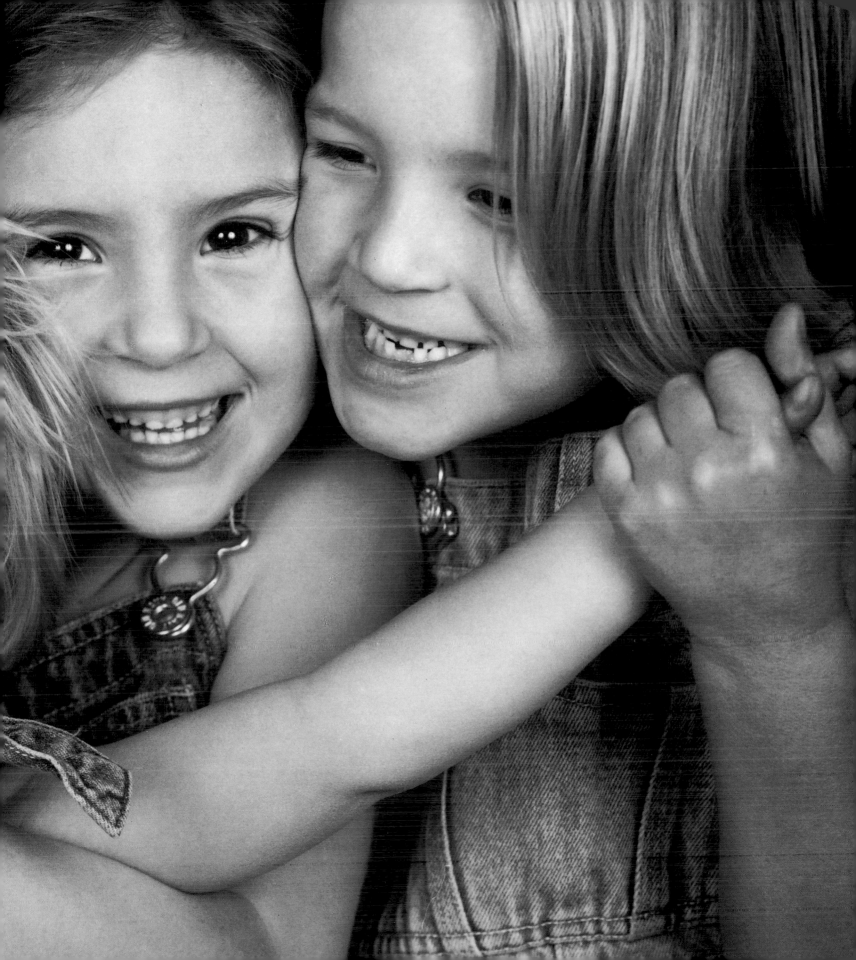

remember what I felt deep in my bones when I was pregnant with my third child, that she was an extraordinarily lucky person, not because she would have my husband and me as parents, but because we had had the foresight to provide her with these two brothers, who, in the natural order of things, would still be part of her life after we were gone. The greatest gift I believe I've given my children is one another. ❧ How difficult it is to fathom, to describe, to deconstruct all this, the commonplace bonds of blood. But we begin to understand it when we remember the moments with them, not the great moments, the graduations, the weddings, the funerals. It is when I think of pushing Theresa around our suburban neighborhood in her stroller and parking her next to my friend Donna's baby sister in a deserted park while Donna and I sat in the grass and talked and the babies babbled at one another and sniffed the yellow summer air. It is when I remember running fast, faster than I ever had before, my lungs bursting in my bony chest, to tell my mother that Kevin had pulled a cement flower pot down on his leg and broken it to bits. It is when I remember listening to Mike, a baby with beautiful blond curls, banging his cast against his crib at night, after he almost cut the end of his finger off on the lid

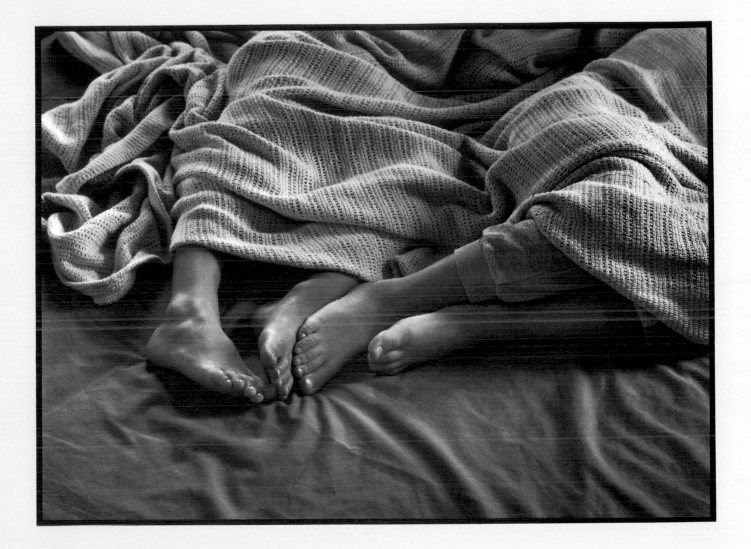

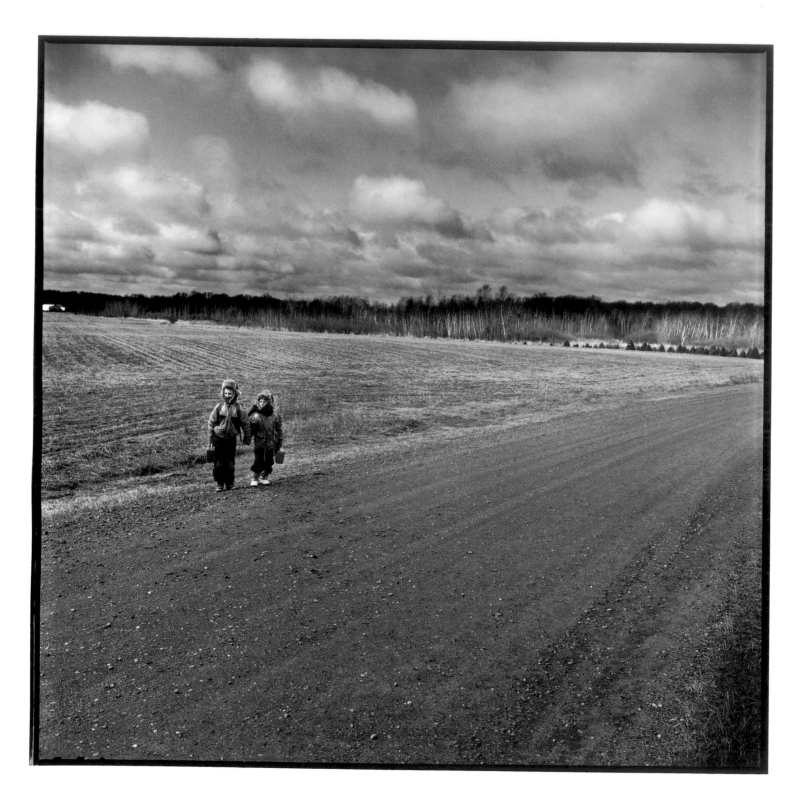

of a tin can. It is when I remember shooting across the living room with Bob

behind me, throwing myself in a chair and raising my flying feet to meet his fists,

trying to get a kick in while he punched away. § Or maybe I find it in a photo-

graph of Bob and Mike and me, taken when we are all under six, still smooth and

unmarked and unknowing, still children. The photographer has placed us in

what is clearly the pose he uses for bigger families, although it must require some

finesse when one of the children is a little girl wearing a full skirt, crinolines.

Bob is sitting between my knees, Mike between his. If the other two had been

born, the photographer would have continued the line, the sibling train. (My

mother-in-law has an almost identical picture, taken at almost the same time,

of her sons.) We are like those matrioshka dolls, one inside another. There

is a sense of connection as powerful as a rope—

or those chains around the ankles that convicts

wear when they're shuttled to and from prison.

Lifelong, irreversible, accidental connection is like that. You can pick your nose,

as one of my kids once told me, but you can't pick your family. § Yet they are me.

I am them. I say that now, knowing how different we are, knowing that some

of us have almost nothing to say to one another that doesn't start with the word "Remember." I say that knowing that sometimes we have been estranged, angry, uncaring. But I suppose that is part of it, too. It is easier to be cavalier when there is a bond that can never be broken. "Flesh of my flesh," they say sometimes in the marriage ceremony, but it's just not true. It is not even true of our children, who are part us, part someone dear to us, loved by us, but not made of what we are made of. But our brothers and sisters: well, it is all the same clay. That is why we can hit them. That is why we can hate them. ❦ That is why we can never really lose them, or we have lost our history, our past, a part of ourselves that we cannot do without. It is a bond as old as humanity, its language scarcely altered from generation to generation, family to family. In 1785 a little girl named Jane Austen was sent off to school in Reading, England, not because her parents thought her ready but because the child demanded to go where her older sister led. "If Cassandra's head had been going to be cut off," their mother said, "Jane would insist on having hers cut off, too." The little girl would go on to write some of the finest prose about sisterhood that has ever been produced in

the English language. And why not? She knew it from the ground up, from cradle to grave. After she was dead her sister burned all the letters that had passed between them. After all, they could tell each other anything, and probably did. ❦ Which is not to say the sibling relationship is straightforward; in fact, it may be one of the most complex connections we ever know. My own children have all loved a book 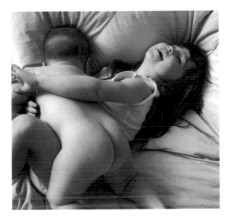 about sibling rivalry called *Julius the Baby* *of the World,* by Kevin Henkes. It is about a little girl named Lilly (well, actually she's a mouse, but she looks like a little girl, complete with red cowboy boots) who acquires a baby brother named Julius. And here is the best part, the part we all can recite from memory, the part where Lilly writes a story about Julius: Julius was really a germ. ◆ Julius was like the dust under your bed. ◆ If he was a number, he would be zero. ◆ If he was a food, he would be a raisin. ◆ Zero is nothing. ◆ A raisin tastes like dirt. ◆ The End. ❦ Well, anyone who has had a younger brother or sister knows exactly how Lilly feels, and exactly how this story is going to turn out, and so did my kids. Because when someone else makes fun

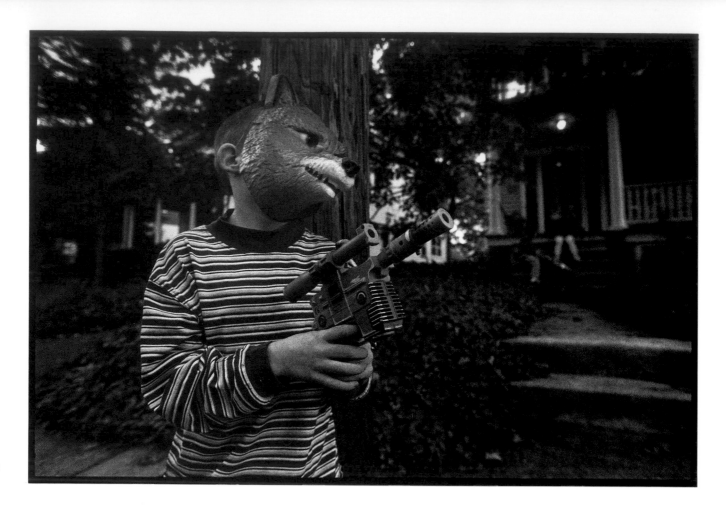

of Julius, the germ, the zero, the raisin, Lilly gets all cold and dark and mean and

makes the malefactor repeat these words, loudly: Julius is the baby of the world. ·

And that is the way it is. My children know it. They live it, every day. While

Christopher allows himself to call Quin a "macho creep," or Quin to call Maria

"you baby," or Maria to call Christopher "big stupid," no one else is suffered

to do so. "Who do you think you're talking to?" one of the boys will say to

another kid who insults their sister. And the answer is implicit: my sister.

Mine. Listen to that possessive pronoun. ·

Of course, it's not as simple as that. The feelings of the stronger toward the weaker, the elder toward the younger, are never simple. And overall arches one irrefutable fact: each has what the other wants exclusively, the love of their parents.

Charles and Adam, the two brothers at the center of John Steinbeck's Cain and Abel saga *East of Eden,* for example, begin the way many brothers do: "The affection between the two boys had grown with the years. It may be that part of Charles' feeling was contempt, but it was protective contempt." But the affection is colored by a pitched rivalry for the love of their father. "You're trying to take him away," Charles shouts, then beats his brother bloody. In the Henkes's book Lilly's parents understand this. They "showered her with hugs and kisses and treats of all shapes and sizes. . . . It didn't matter. Nothing worked." ❦ Well, of course it didn't. It means something that in *Dr. Spock's Baby and Child Care,* the only mention of siblings appears in the section headlined "Jealousy and Rivalry." Penelope Leach, in one of her child care books, described it best: suppose one day your husband comes home and says that he is about to acquire a new wife. She is younger and cuter than you and will require more care and attention. But

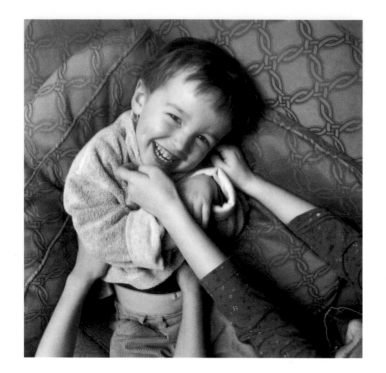

30
.

this does not mean he loves you any less. ᛋ Well, it does make the ground rules of

the relationship quite vivid, doesn't it? Each time my mother went to the hospital

in the middle of the night, I can remember thinking it: less for me. My father did

his best while she was gone, but the school lunches were badly made, or not made

at all, and the dinners were haphazard, Lenten meals, grilled cheese sandwiches

and tomato soup. And then our mother was home, with

someone small, almost subhuman, someone so

clearly in need of intensive care. Less for me.

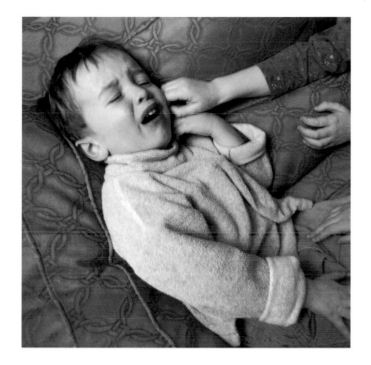

Just . . . less. ❧ And yet, without even knowing it, I was getting more, learning more, knowing more about human relationships and the amazing variety of character and response. Incredibly enough, my college psychology text has only a single reference to the sibling relationship. It reads thus: "More than 80 percent of American children have siblings. In the child's interactions with them, he may learn patterns of loyalty, helpfulness, and protection; or of conflict, domination, and competition—and these may be generalized to other social situations." As my kids like to say, "Duh." Virtually all of the rest of the material in this section of

the book is about the oldest child, which younger siblings would tell you, wryly, bitterly, is just about the way the book of life is written, too. ❧ In sitcoms and movies, comics and cartoons, the sibling relationship is often portrayed as just one practical joke after another, as though all of childhood was short-sheeting and prank calls. One day on the radio there was a call-in contest: what was the worst thing your brothers and sisters ever did to you? One woman called to say her sister had put her in the dryer with a load of towels; another said her older siblings had folded her into a convertible couch. (As the eldest of five, I will say

that while both of these sounded like extreme examples, neither sounded implausible to me.) Torture, mental and physical, is a recurrent theme: biting, kicking, telling friends about the night you had the dream about going to the bathroom and actually—well, you know. ❧ But that is the easy part, the surface manifestations of what it means to live in a house with other people, related by blood and by their equal right to the towels, the sofa, and the Oreos. The hard part, the deeply individual part, is the alchemy. What is it like to be the younger boy if your older brother is a gifted athlete with an easy way with women? What is it like to be the middle of

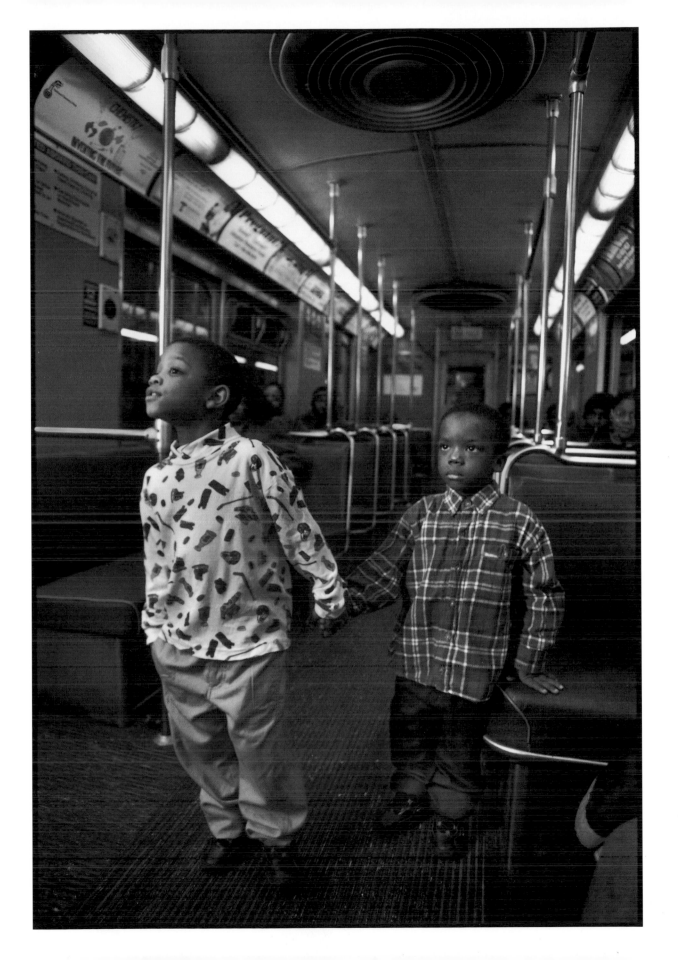

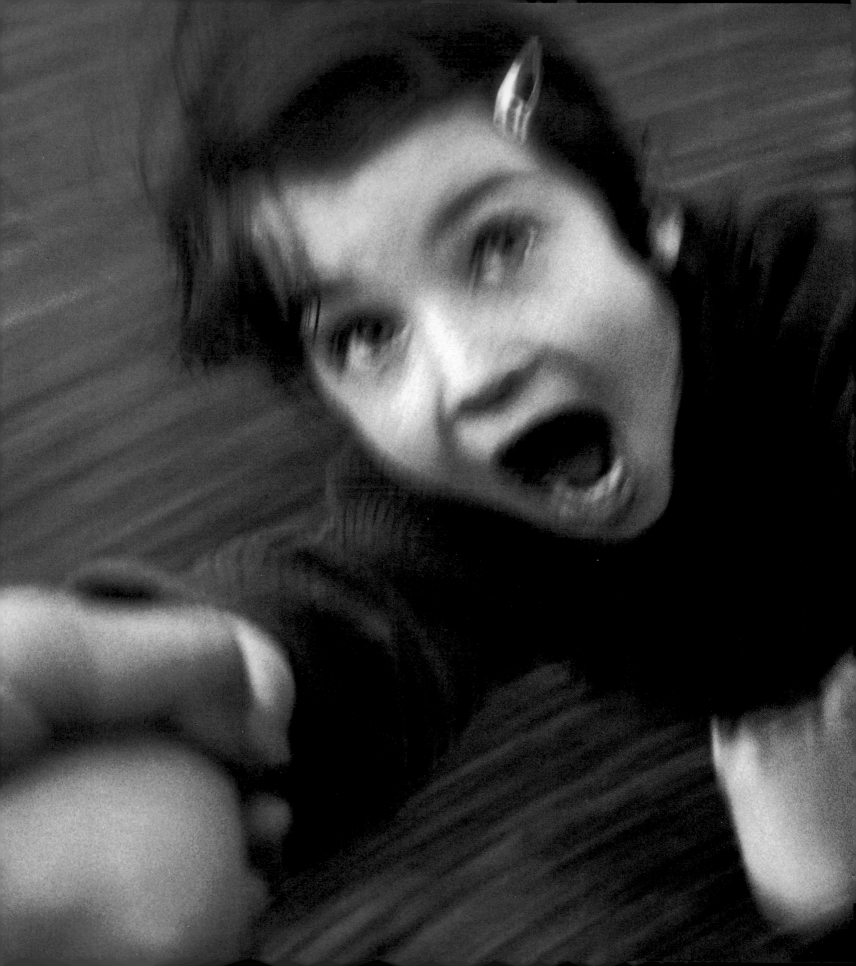

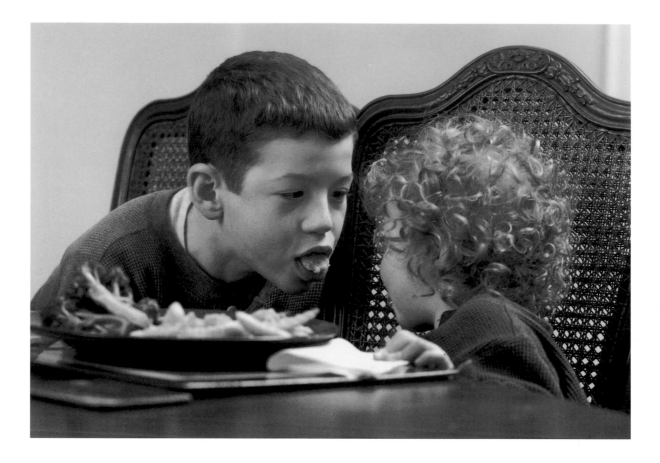

three sisters when one is just like Mom and the other just like Dad and you are—

well, just like you? If we are so clearly defined by our childhoods, how can we

help but define ourselves except in terms of what our sisters and brothers are,

what they think of us and how they treat us? How much of our character is

essential, how much a chemical reaction, against sister, against brother, against the

family mythology that so early on assigns roles: you are the good child, you the

clown, you the little lady, you the troublemaker. The family is a country from

which it is impossible to escape when we are young. It creates a place for each of us, whether we like that place or not. ❧ My husband is the eldest of six boys, and one of his brothers once told me that the rest of them had a clear sense of where his future lay: "either pope or president." I am the eldest of five, and when my brother Bob heard that, he laughed. "You two were made for each other," he said. So Bob established his persona partly in opposition to mine, and Mike to Bob's, and so on, and so forth. Our families are like houses: you get the room that is not yet filled. Sometimes it is a narrow one. Inevitably, you think someone else has gotten a better deal. ❧ My second (and, not coincidentally, middle) child has a one-word clarion cry whenever he feels put upon. "Favoritism," he intones, almost as though the word was set to music, a recurrent chord. "Favoritism!" a standing joke in our household has been the moments when I pull one of the three aside and say, with great seriousness, "Don't tell the others, but you are my favorite child." The joke is that it is understood that I say this to each, sometimes within the same five-minute period. The oldest smiles

tolerantly, as though to say, "I don't really need this." The second grimaces; the trick is old, and he's not buying. The third, and youngest, snuggles close and laps up the words like a kitten with a saucer of milk. If I am mother earth, a good bit of their relationship consists of being my competing moons. And so a good bit of their relationship with one another consists of grievances: "he got to," "you always let her," "she never gets in trouble when," "I always have to." ❦

There is some truth in these grievances as well: each child in a family with more than one gets a different set of parents, different in age, in experience, in position at the time of the child's birth. By the time our third was born I didn't sweat the small stuff, which sometimes meant I missed the little moments. But that third child has something her older brothers do not : two older brothers. Ask her today and she will tell you that they are the bane of her existence. And in many ways she is absolutely right. Here, for example, is some representative dialogue from a short ride in the car with three people who have been assured at least a million times by an interested party that they really do love one another: *"I like this song."* ❧ Loud sigh from the backseat. *"Maria, this song is so*

stupid." ✦ *"It sounds just like their last song."* ✦ *"I liked their last song too."* ✦ Loud sigh from the backseat. Ten bars of innocuous music. Another sigh. *"Can we change this?"* ✦ *"No! I like this song. You guys always get to listen to what you want to listen to. I never get to listen to what I want to listen to."* ✦ Snort from the backseat. *"You listened to this same song yesterday in the car."* ✦ *"No I didn't."* ✦ *"And it's such a stupid song. It's so . . . predictable."* Another sigh. Maria bursts into tears. ✦ *"You always make fun of my music and you*

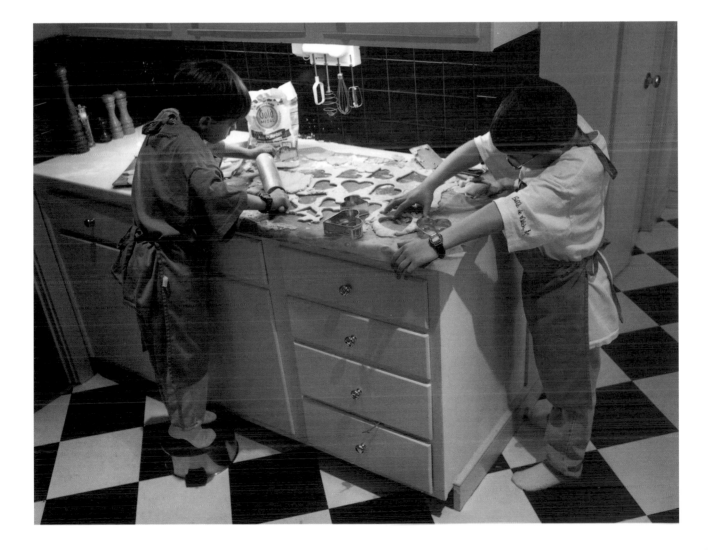

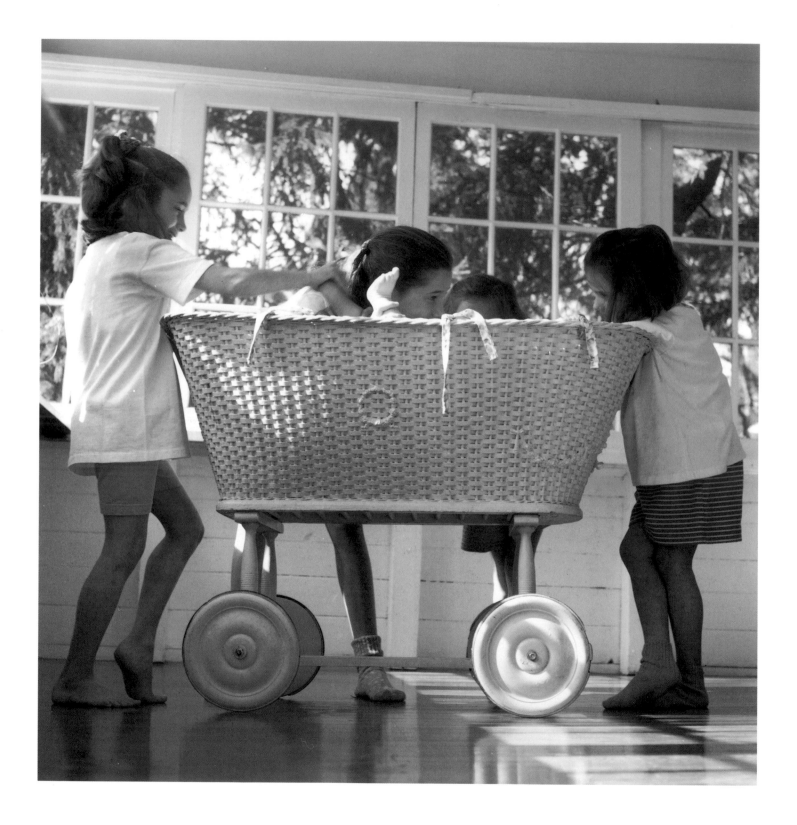

*never let me listen and then when I do listen you . . . "* ◆ *"Maria, we're not making fun*

*of it, we just don't . . . "* ◆ *"Maria, you don't have to cry about everything just because . . . "* ◆

*" . . . like it necessarily but if you like it that's all right for you but we don't want to . . . "* ◆ *"learn*

*to disagree without crying . . . "* ◆ Sobs. ❧ Of course it is easy to see what is wrong

with this scenario, particularly if you are Maria. She is too young to have the vast

14-year perspective on popular music that her oldest brother had at the time of

this conversation, nor is she experienced enough to have learned all the tricks

of twisting discussion the way the second boy has learned from long experience

from the first. Raw emotion is often her tool of choice, which she understands

intuitively is useful but second rate; she would prefer the bon mot, but each time

she gets a handle on more sophisticated auto travel repartee, the other two have

done so as well. ❧ She is in no position to know that this will continue until,

sometime after the age of 18, age becomes less determinative than experience,

and she will do and discover things her brothers do not, things that will impress

and educate them in ways that are less possible now, now that all three of them

move in some lockstep of personal experience. I know this dialogue in the car;

I can reproduce it effortlessly, not only from listening to these three, but from

remembering we five. There is a *Far Side* cartoon by Gary Larson showing two small octopi in the backseat of a car with their parents; the caption reads

"He's touching me! He's touching me!" It is the work of a man who grew up with a brother, and speaks to all of us who have had siblings. ❦ But look again at that conversation in the car, and you can see, in miniature, much of what makes the sibling relationship so powerful and so

important. Beneath the bickering is something else, something unusual and valuable in human intercourse. There is little pretense in how these three people talk to one another, little posturing or false politeness. They are direct in a way they are direct with few others. They have known each other, literally, since the day they were born. They have shared, beds, breakfasts, heartbreaks. The masks we assume throughout our lives fall before the weight of so much everydayness.

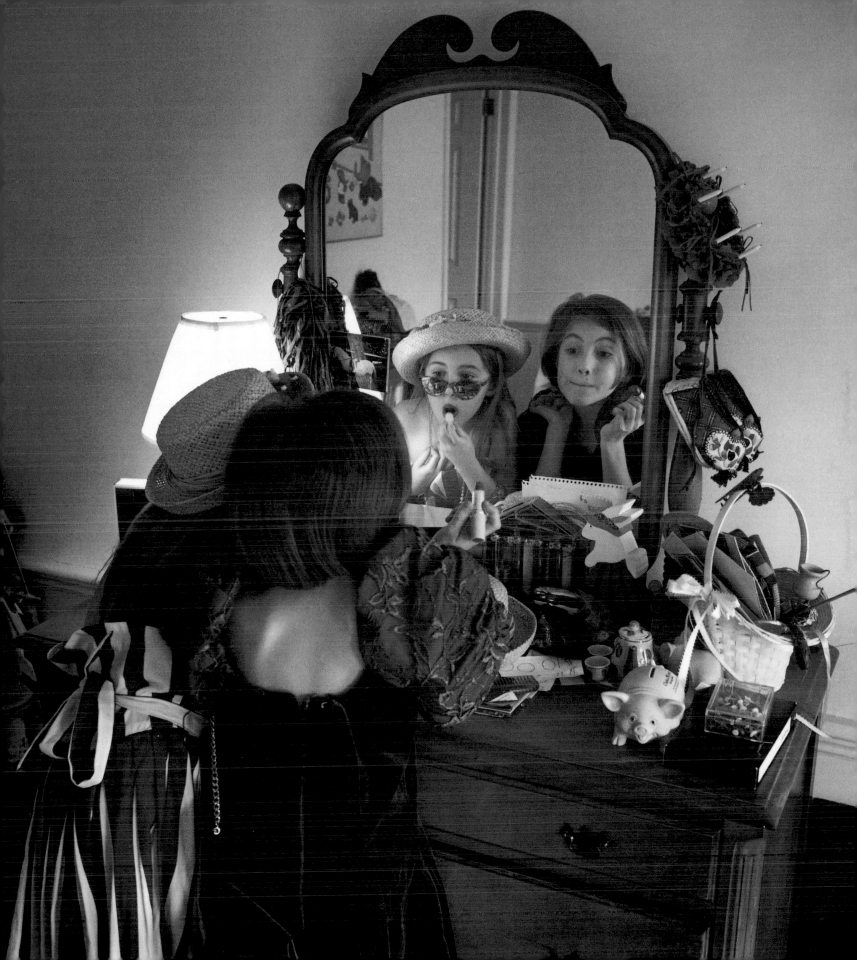

With one another they will begin to learn how to be themselves for other people, at least for people they love and live with, and truly trust. ❧ Oh, they try it on in this laboratory, for that is what family life is, a laboratory in which to try the experiment in living in a smaller, more forgiving world. The boys learn that bullying may give them a momentary feeling of power but will not yield the desired result, which is to change the radio station. They learn that the tears of others make them uncomfortable, and force them to soften their hard line (although not abandon it). The lessons Maria learns are more easily seen over the long haul: she is both one tough girl and yet intensely sensitive, both a result largely, I think, of her relationship with her brothers. ❧ They are all very different, and quite similar, as close as a litter of kittens and, occasionally, as distinct and separate as two strangers on the street. Both things will continue as they all grow

older, until they will sometimes seem like lab experiments to one another, a study in the random variations of genetics. (How come, my sister and I like to say, the boys got all the looks and we got all the brains? Just kidding. Well, sort of.) And in the futures of their siblings they can chart their own roads not taken.

# How can we explain it when one child becomes a butcher and another a zoologist?

Perhaps the parents treated them differently; perhaps there was some crucial moment in both their lives that led in different directions. Or perhaps it is only a testimonial to the great diversity of human nature, humankind. ❧ There are families in which the jockeying continues past the who-controls-the-radio-in-the-car stage, when grown men are still trying to prove which brother is smarter, stronger, better. But most of the time that evaporates as the years go by, and all that is left are memories, and love. But it is not a love like most others. I suppose it is a little like the way

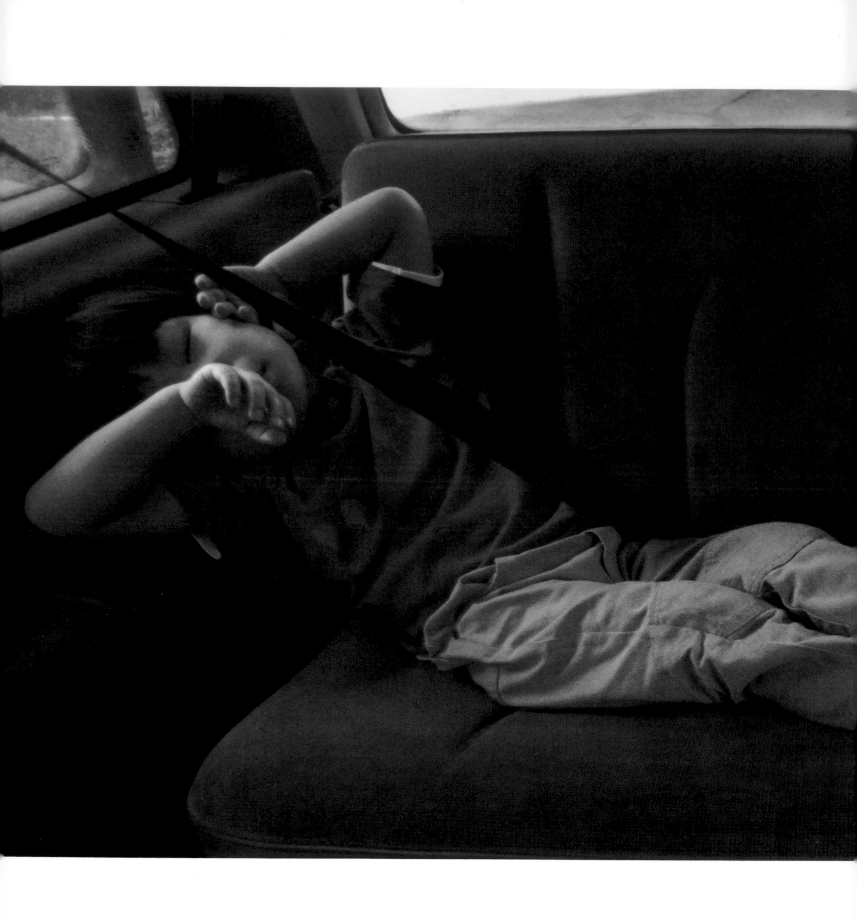

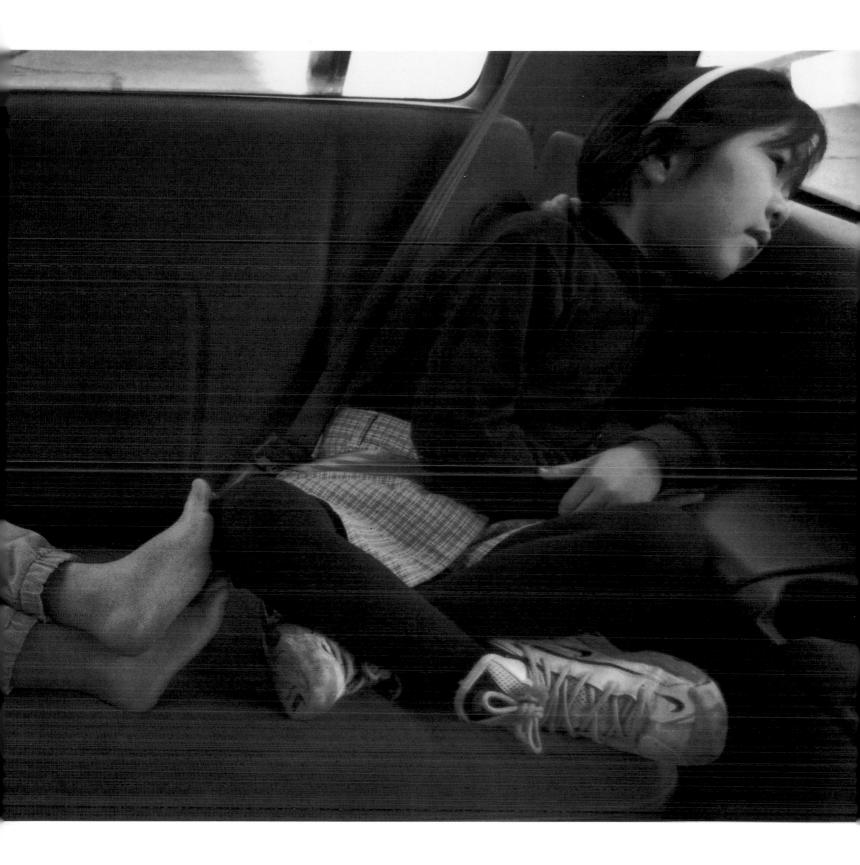

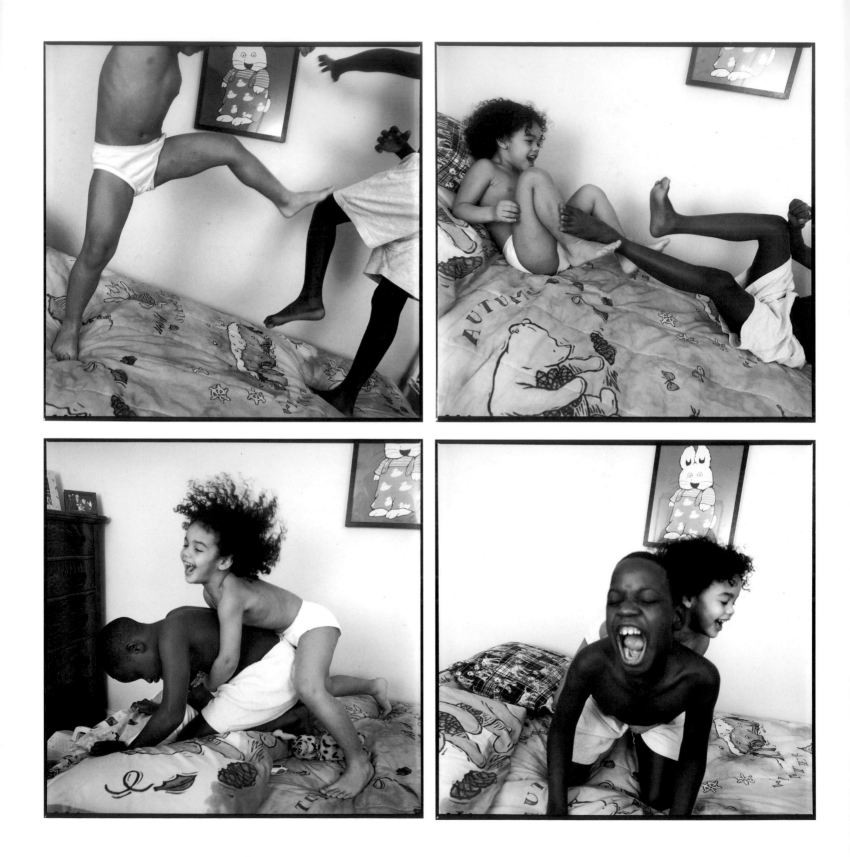

I love the little china dish on my dresser in which I leave my earrings every night.

It's pretty, and perfectly shaped, and I scarcely look at it most of the time. But

if it were not there, if I broke or lost it, I would be off kilter. I am used to it. It

is one of the few possessions that I have had for many, many years, through

apartments and houses, single life and married life and life as a mother. ❧ And

that is how it is with my brothers and my sister. I have had friends who have

lasted over the years, and some who haven't, sad to say. And there have been times

when I have not seen or talked to my siblings for months, occasionally even

years. ❧ But I've been a sister longer than I've been almost anything else in my life.

Here I stand in my kitchen with Bob, both of us with almost the same amount

of gray stippling our dark hair, having the comfortable, careless conversation

of two people who know things about one another. And it suddenly occurs to

me that he is the only person I have ever beaten up.

More than once, too. Two of my brothers-in-law were talking the

other day of how they once came to blows, and their father came between them, repeating the words, "Brothers don't fight. Brothers don't fight." I loved my father-in-law, but here's my response to that particular piece of family wisdom: the hell they don't. Of course I did hit Bob. Of course I could. He was my brother. That explains everything. ❧ If he was anyone else I once hated so much, I wouldn't even know him today. If he was anyone else as different from me in interests and activities, I wouldn't even know him today. If he was anyone else from whom I'd been estranged as a young adult, I wouldn't even know him today. But he isn't anyone else. ❧ We both have families of our own; it's not that we need more relations in our lives. But I know what our mother meant now: in some fashion, we are all we have left. So much of our past life is gone. Someone else lives in the houses; we no longer see the schools. Our mother is dead; our photographs have that peculiar yellowish tinge that marks them as artifacts of some rapidly disappearing past.

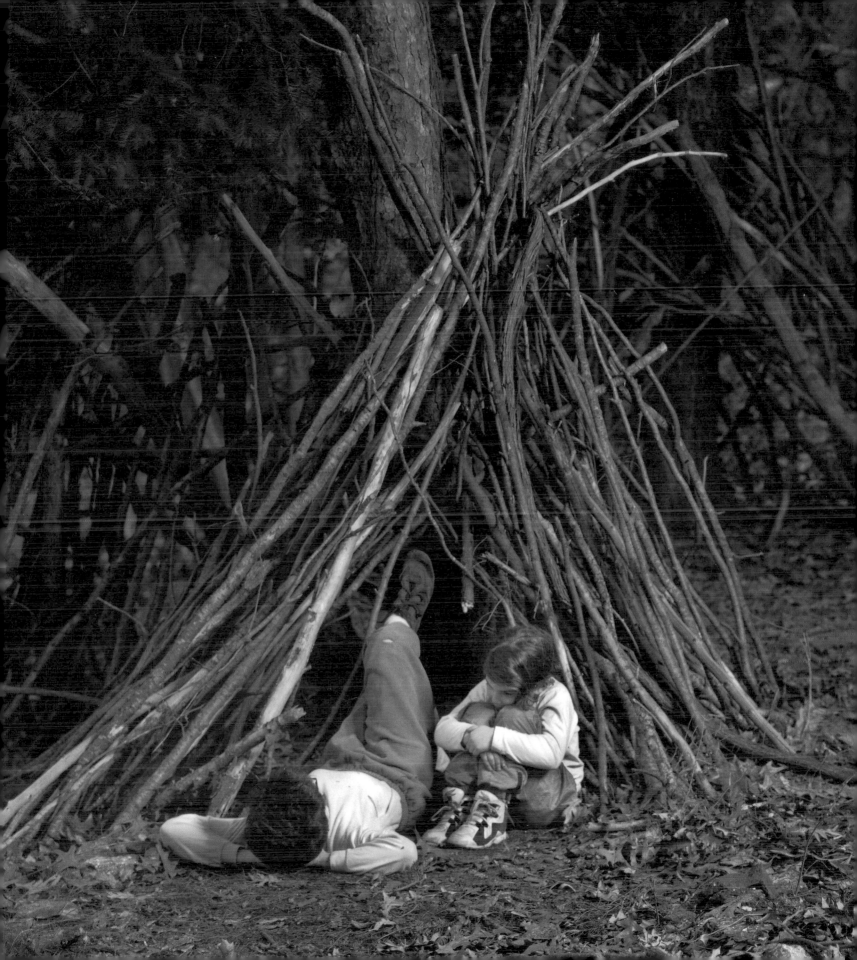

In one another we remember where we have been, who we are. There is a little boy inside the man who is my brother, a little boy with thick glasses, bright blue eyes, a brush cut and a squint.

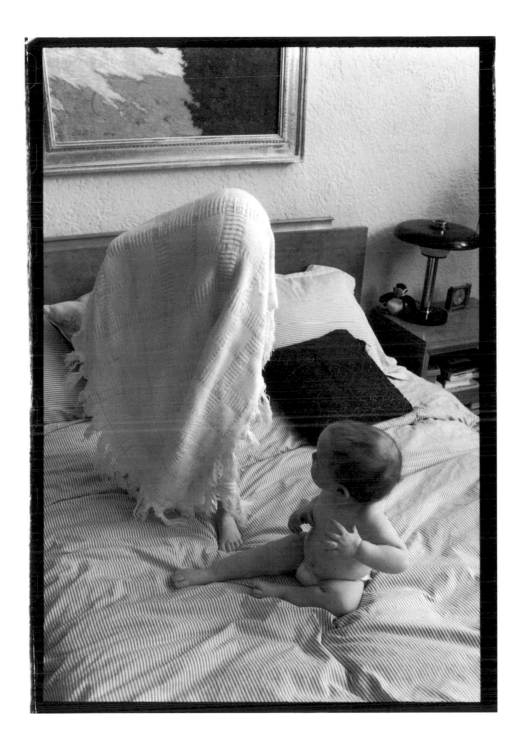

Oh, how I hated that little boy.
And how I love him, too.

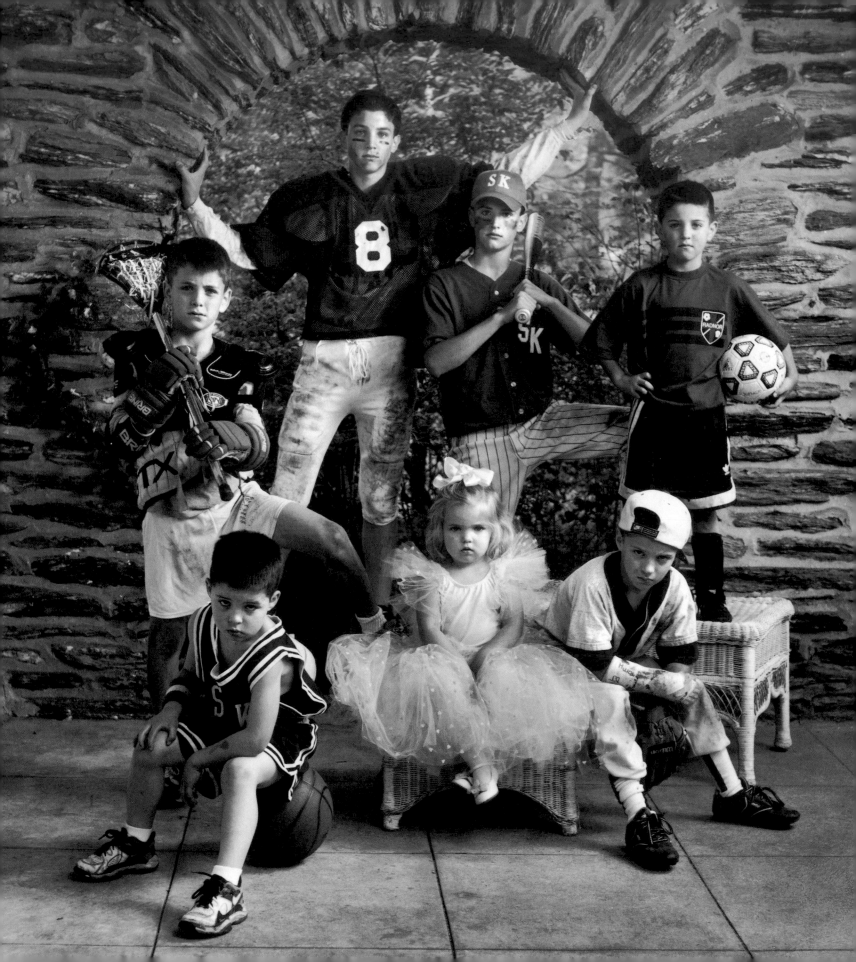

# The Baby

Maria is crying, full to the brim with her habitual grievance, her status, or lack of same. ❧ "I'll always be the youngest," she wails, "always, always. Even if I live to be 50 years old, they'll be 55 and 53. When I'm 18, they'll be 23 and 21. No matter what I do, they'll always be older than me." At least, I think to myself, she can do the math and get it right. I'm convinced that's how she learned addition, by working out how much older her brothers would be than she was at any given moment in her life. ❧

Having siblings means that someone has to be the youngest one, forever and ever, and in this family it is Maria. She sees this as nothing more than a set of perpetual shackles. It is the cause of all her troubles. In some ways it is the cause of all. For as long as I have known her, since she was passed to me, all purple and disgruntled by an obstetrician who had stitches to set, her life has consisted of keeping up with the Joneses. The Joneses are her brothers, and oh, has she kept up. ◈ "Boys," she would shout with the soft unformed consonants of babyhood as she toddled

around the house. "Boys! Where are you?" Perhaps my most indelible image of her, all her life, for me, will be the afternoon when I looked up from my book by a chaise at poolside and saw her, naked, round, rosy and perfect as a Sistine Chapel cherub, standing at the end of the diving board, looking into the clear blue of the water at the deep end. She was not yet two but she could undress her-self as swiftly as a stage actress with a quick change between scenes. When she saw me staring, my face surely a study in frozen terror, she scowled extravagantly. "Boys do it," she said succinctly, and jumped. And never stopped jumping. ◈

All the things I cannot do, that Maria does unthinkingly—ah, I cannot even keep

track of them all. Roller coaster rides. Four square games. Soccer. Cocktail party

conversation. (Honest to God. It is not uncommon to find her, at a party at

which she was expected  to be seen and not

heard, chatting away to a group of dazed

grown-ups.) She is easy with people in

a way she cannot appre- ciate because

she has never known anything else. She

is happy with older children because she has always lived with them. She is careful

with younger ones because she understands their feelings. She started ripping

off her own diapers at 18 months, throwing them to the floor as quickly as I

could put them on, until finally after a week of this I gave up and put her in

underpants, which she never, ever soiled. She knew where you were supposed to

go to the bathroom; she'd seen it done by people not much bigger than her often

enough. Of course, the biggest difficulty we had was that she insisted on trying

to urinate standing up. ❦ But she is utterly incapable of seeing the advantages in

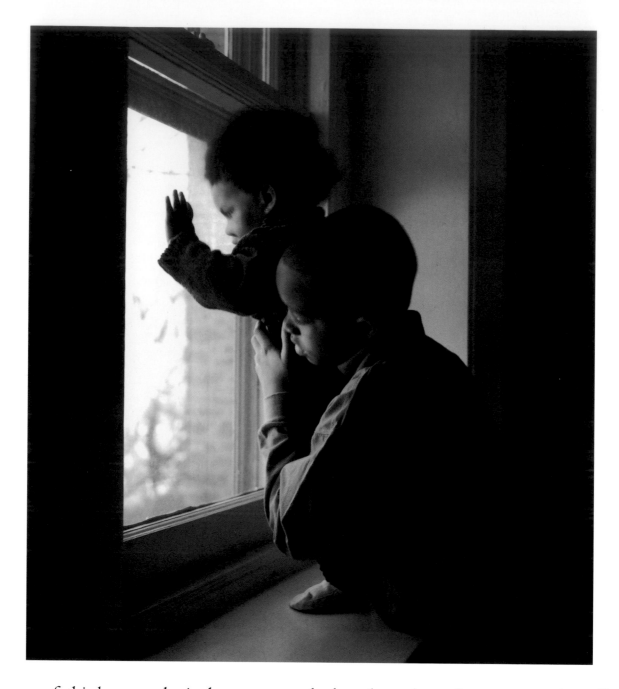

any of this because she is the youngest, she has always been the youngest, she will

always be the youngest. A discussion about the legal drinking age can set her

off for half an hour. She cried at her brother's grade school commencement, not

because she was sorry to see him go, but because she realized that by the time

her turn came around her father and I would be attending our third such, surely

tired, jaded, unimpressed. "I'll never be first at anything!" she

wailed. § What can I tell her? She knows I am an oldest child, which is as differ-

ent from being the baby as sunshine from storm, night from dawn, earth from

moon. I have always had an enduring belief in my own singularity. Try as they

might to ignore and belittle it, my brothers had considerable belief in my author-

ity. And my sister, the baby, more than a decade my junior? Well, she sometimes

seemed to believe that God was a woman, and I was she. Some of this grew out

of the most meaningless surface details of our existence together. While the rest

of them were still learning to add and multiply, I was admitted to the mystery of

fractions. While they were still taking the school bus, I could drive. They dated; I

married. § And they learned by watching; oh, how they learned. The youngest

children I know rarely work themselves into a lather; they've seen others lather in

their stead. They seem somehow easy in their skin: they have both a place of

honor and regard and the ease of having had someone else break all the ground.

Each of us rides the toboggan of experience down the hill; by the time it is the turn of the youngest, the hill is smooth and slick and perfectly prepared. How luxurious that seems to me, to have someone else pave the way, make your mistakes for you, break your parents in. By the time

Maria gets to the classroom of any teacher in the school where both her brothers have gone before her, she will have heard endlessly about that teacher's quirks and foibles. She will know how to negotiate the strictures, how to hand in the homework. § I know a woman writer who is the youngest in a very very large family, and who seems to me to embody all that that can mean. She has a kind of befuddled, frazzled manner much of the time: the phone number can't be found, her purse is missing, her notes are muddled. She is nervous about the speech; she lost

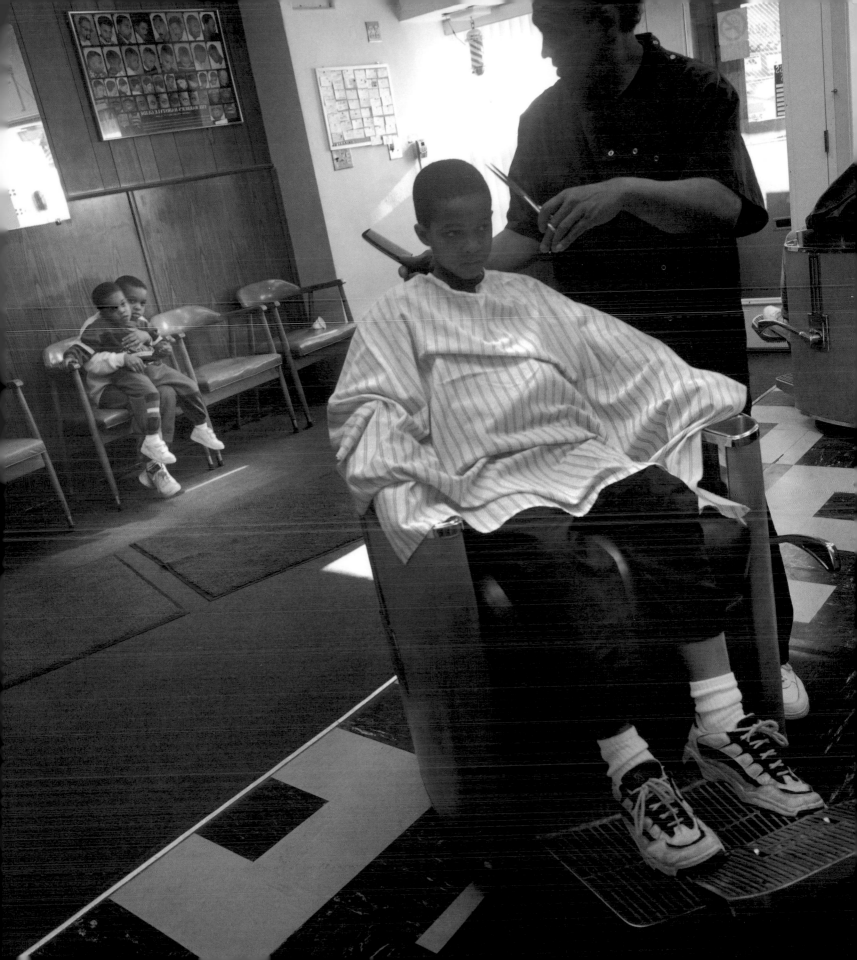

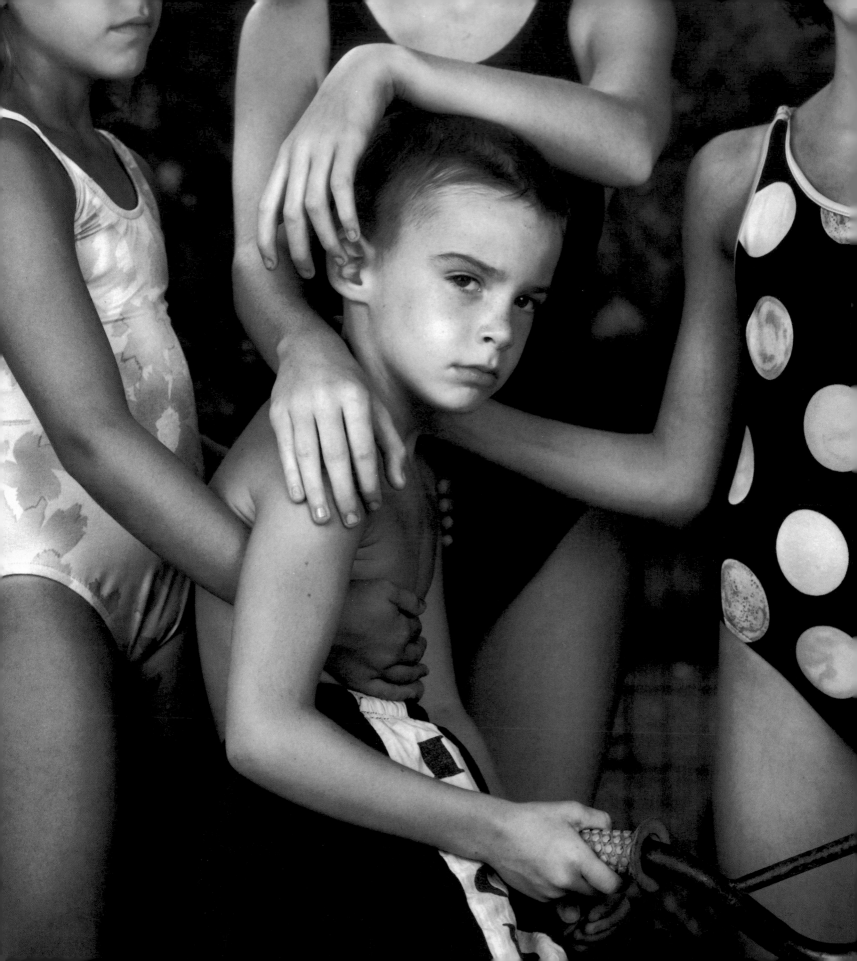

the statistics. She has clearly spent much of her life with other, older people taking care of that sort of business, tsk-tsking loudly and then bailing her out. Out of that she has developed a charming, surprising air of ineptitude. § I say surprising, because of what follows. When she sits down at the computer or steps up to the podium, she is magnificent, all certainty and charm. It is quite an act, this. She is not afraid to be both vulnerable and competent, both child and woman. I could never manage it in a million years. But all that petting of the baby, and all those lessons learned watching the bigger ones, surely has paid off. § So Maria is right, I suppose, when she says I don't understand how terrible all this is. I see familiarity; she sees contempt. I remember being eternally ag-grieved by the extent to which I believed my sister was the beneficiary of more permissive, more comfortable standards. The curfew edged past midnight; the punishment for bad grades grew less stern. I lived with my boyfriend and my

father blew a gasket; my sister lived with her boyfriend and her father was resigned, even philosophical. The two were scarcely the same father, so different were the reactions. § But we both gained, of course: me from my sense of primacy, she from her sense that she had nothing to prove. She lived and learned, which is what the youngest has such a rich opportunity to do: to simply watch, and understand. This is what it is like when people date. This is what it is like when people fight. This is what it is like when people fail. It is as though we older ones are putting on a play, or a demonstration: the way it feels to break a bone. The way it feels to break a heart. And so on. § Despite what Maria says, I have managed to figure out how she feels. I'm most conscious of it when I think of the year I spent dating a man nearly two decades my senior. All of my wild enthusiasms were old news to him. Sushi? Bermuda? Arthur Miller? Fred Astaire? Yawn. Been there. Done that. To be fair, he was gentle about it all, but the truth was that I was just discovering a world he had learned to take for granted. There

were many reasons we parted, but one was that I felt as though the pearly sheen of discovery was off everything for me while I was with him. ❧ Well, Maria's brothers are only five and three years older than she (". . . and when I'm 60, Quin will be 65 and Chris will be 63!") but they do some of this, too. They've read the books, seen the movies, visited the museums, and they're not shy about telling her, not just what they thought, but what she should think as well. There's a fine line between advice and dismissal, particularly when you're too young to have learned tact. Older siblings don't often walk it well. ❧ But youngest children learn early on not to follow. They have so many models: this brother, that brother, the parents, the cousins. They come to know that there is no one way, and that if they want to find some way to stand out they will invent their own. They take chances. They go out on limbs. And diving boards. What bliss, to be the baby, and to find the many ways there are not to behave like one.

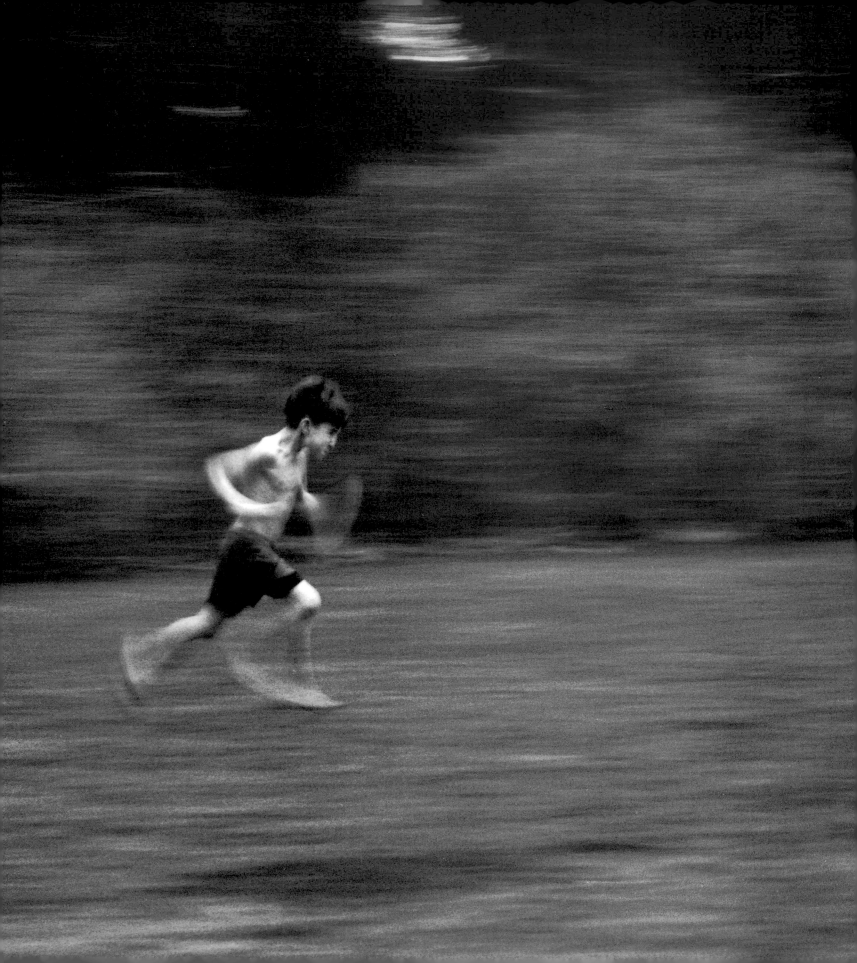

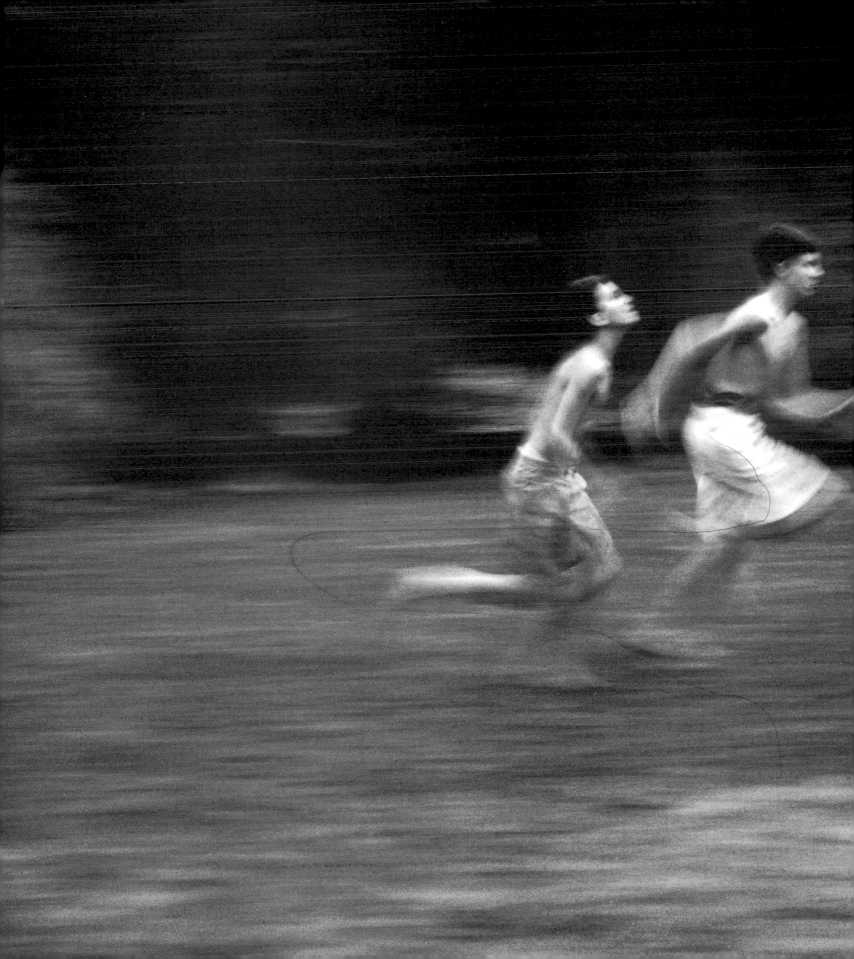

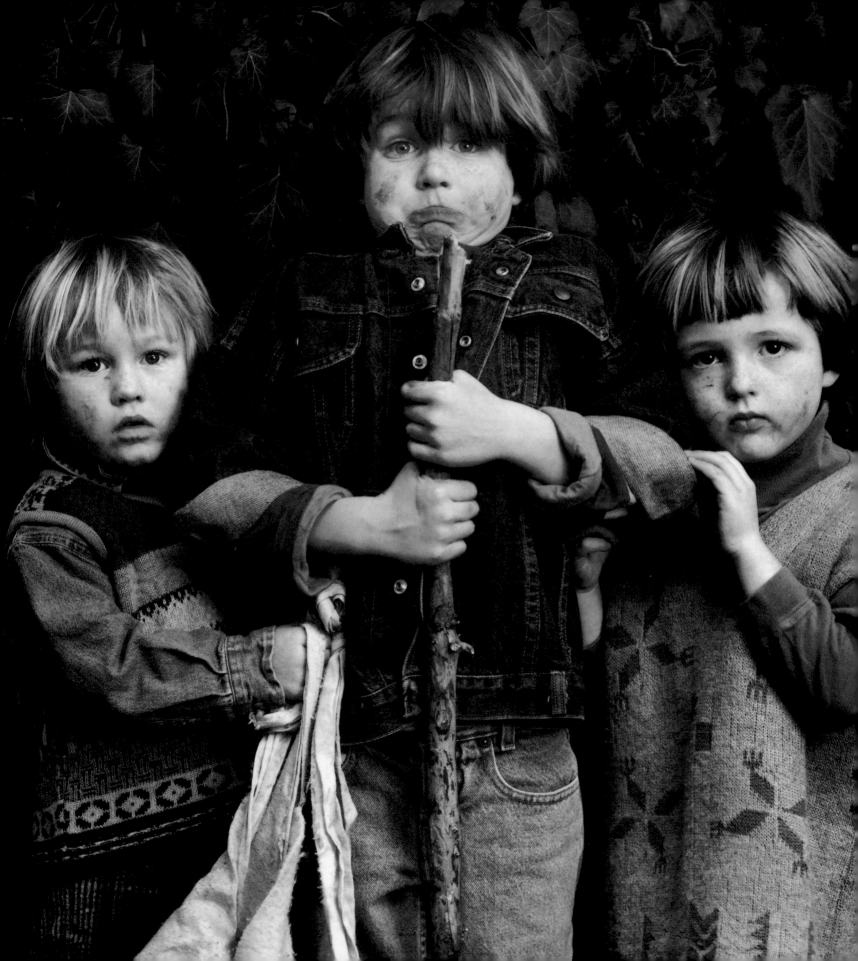

# Differences

In the movie *The Godfather* there are three of them: the smart thoughtful one, the stupid childish one, and the macho uncontrollable one. In *Little Women* there are four: the homebody, the writer, the artist, the child. And in Jane Austen's *Sense and Sensibility*, they make up the title. One thinks; the other feels. ❧ They are, therefore I am not. That is the crux of the sibling relationship. We define ourselves in terms of our differences from those who share our life. As though our households were

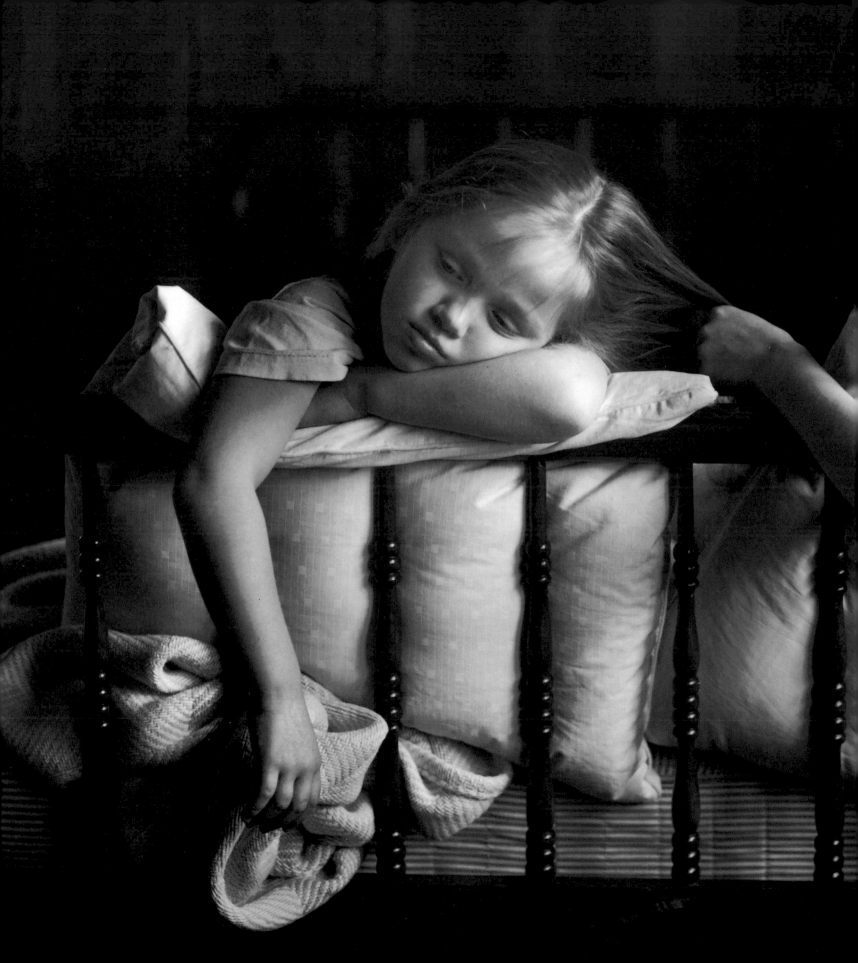

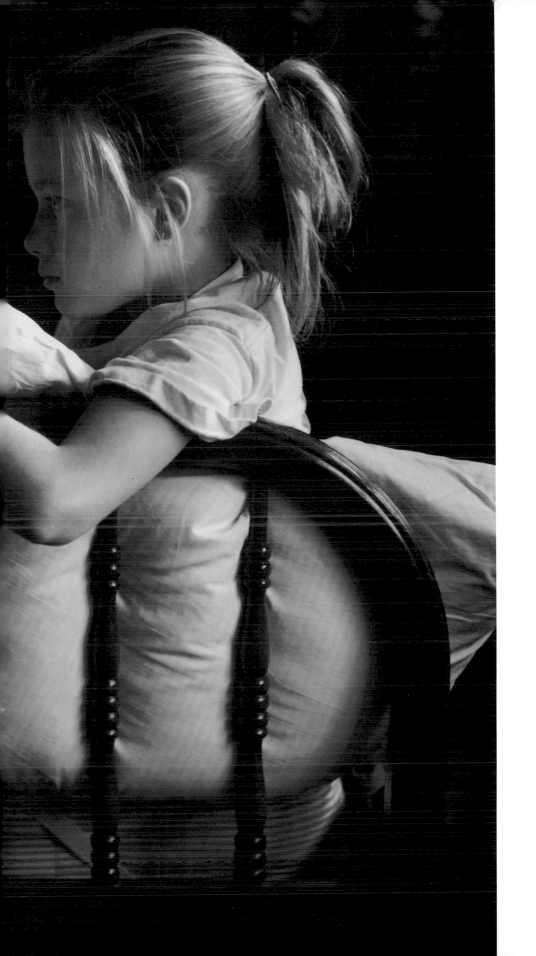

They are,
therefore
I am not.

theaters, as they are, we enter on cue and take the seat that is not filled. The clown, the thinker, the quiet one. The role is cast. Sometimes our parents do the casting: Mrs. Portnoy turned her son into a prince, so his sister became a peasant. Sometimes it just happens, the strange synergy between related strangers whose lives depend on one another. My husband is the oldest of six brothers: when they stand together it is like looking at a pie chart, in terms of who got what—

ambition, creativity, warmth, whatever. It sometimes feels as if they played a game of poker for character traits and life's work, and everyone wound up with something different. ❧ Some of this happens early on in life. The roles are set, set in stone, and variations are scarcely tolerated. While we expect other people to change and grow, our siblings are sometimes set, paralyzed in the amber of their family roles. Just look at the Marx Brothers. Of course it is

comedy; of course they are archetypes. But remember that they are indeed brothers, and that they choose the parts they play in those movies: the smart curmudgeon, the bumbling idiot, the happy fool. And remember that over the course of many years they continued to play those roles onscreen, with one another. ❧ They are, therefore I am not. My brother and I, in high school, looked like the two leads in some bad fifties biker film, he in his black leather jacket and greasy pompadour, me in my plaid pleated skirts and monogrammed sweaters. Our grades and activities relative to these appearances were just about what you would expect, and so the sentence my brother heard most during high school was this one: "You're Anna Quindlen's brother?" ❧ Well, of course he was. What did they expect him to be, a duplicate of me, a copy, the understudy, the second string? A strong personality—and he has a strong personality, as strong as mine, in some ways stronger—finds a way to declare itself. Lined up in picture after

picture, gathered together around countless dinner tables, seated sweaty shoulder to sweaty shoulder in countless cars, we declared ourselves in terms of one another, in terms of how we were alike and, more useful, easier, in terms of how we were different. It was never clearer that we were complimentary than when I had stockpiled my extracurricular activities, my carefully cultivated sociability, into a spot on the high school homecoming court and my brother took his completely spurious tough-guy menace to the halls, parking lots and rest rooms to threaten other pupils if they did not vote for me. ৡ Sometimes siblings feel as though there is no role for them; that's why middle children often find themselves in some colorless limbo, between the powerful eldest and the beloved baby.

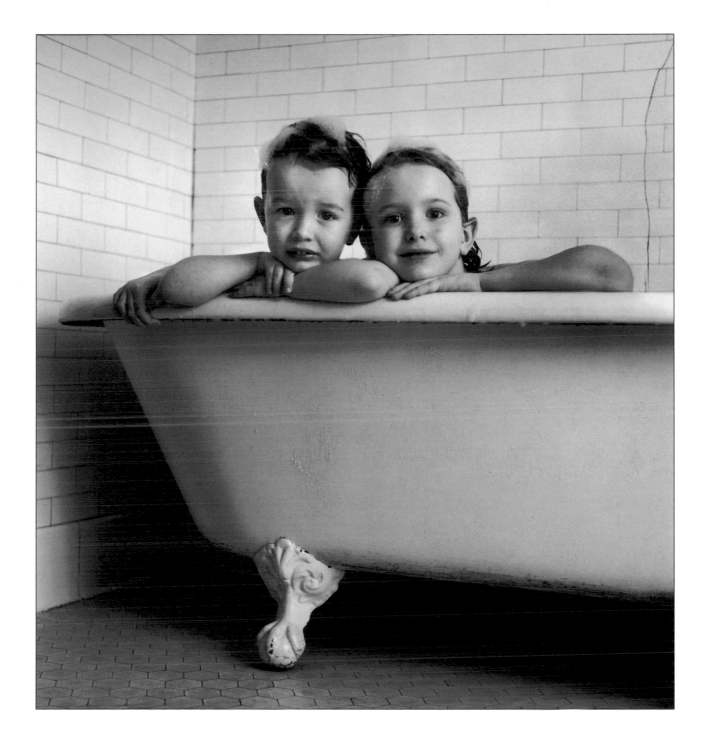

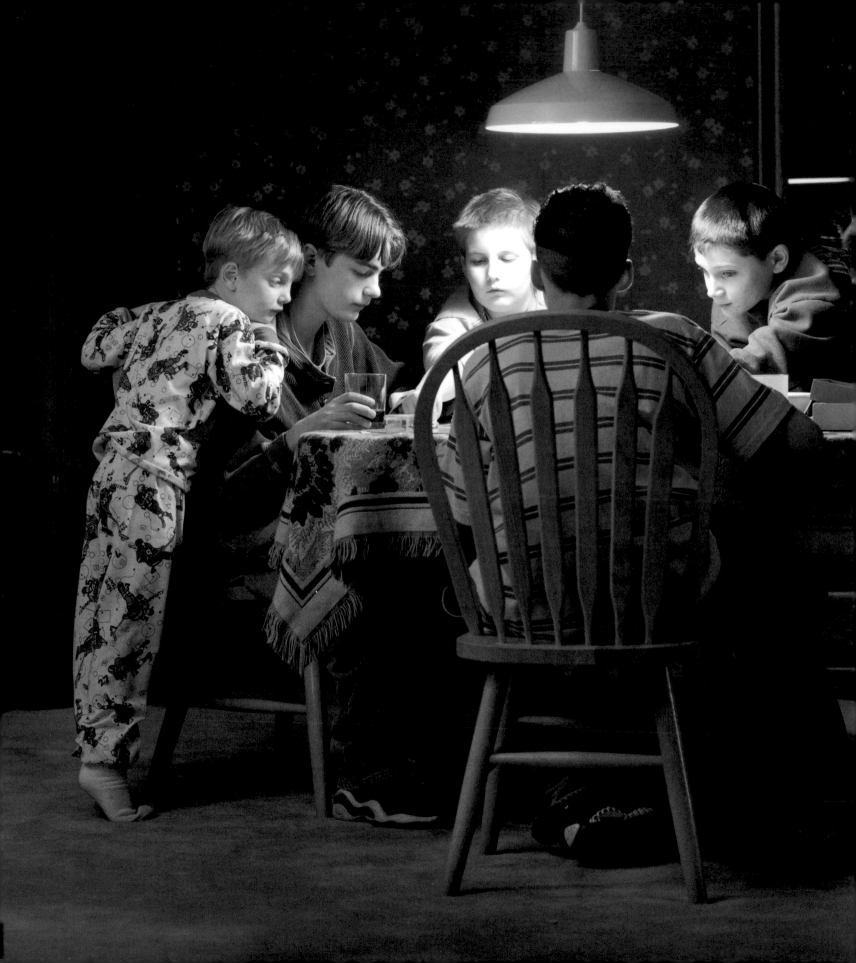

Sometimes circumstances can shift or change the roles. Consider the Kennedy

boys, the first family of 20th-century American politics. Young Joe was once the

charismatic leader, the one of whom much was expected. The other boys got

his leavings. So Jack was the sickly one, Bobby shy, Teddy the ebullient baby. But

then Joe died, and Jack had to become the leader, and slowly gained the mantle

of gravitas leavened with the lustre of charm. And then Jack died, and Bobby

assumed both, although a little less convincingly. And then Bobby was shot, and

Teddy became the leader, less convincingly still, a role shift too profound, from

youngest to eldest, to be easily assumed. His public life seemed to be a lesson

in what it looks like when a youngest child suddenly tries to behave like the eldest

one. ❧ My father was the middle child of eight, and to some extent he continued

thus his entire life, the clown, the bad boy, the kid with the round face and

the cowlick in the family portraits, the look in his eyes and the corners of his

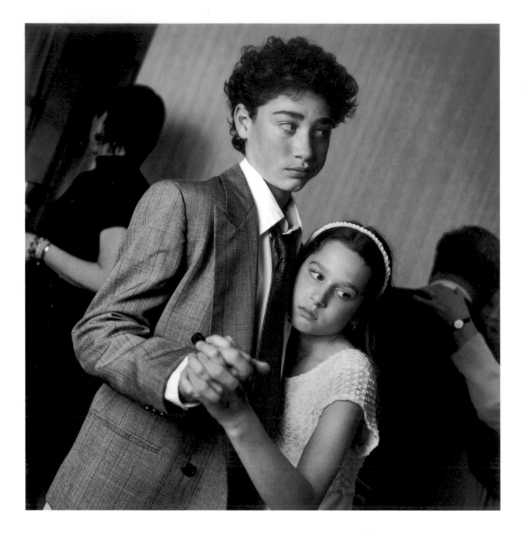

The strange synergy between
related strangers whose lives
depend on one another.

mouth seeming to betray the frog in his pocket or, later, the cigarette. Father, grandfather, veteran, successful businessman—in the last half century he has obviously transcended his childhood, although he is still an inveterate joker. Yet to see him with his siblings over the years was sometimes to watch a person revert before your eyes. His role in the family was radically different than his role in the world. But it was also the bedrock of his character, that center point from which he moved himself through all his other roles. ❧ This does not always make us like ourselves, particularly if we are cursed with that perfect sibling who seems to travel swift on silver skates over the surface of school, home, life, everything. There can be two perfect children in a family, or even a whole houseful of them, but it doesn't happen often. Some of the most painful passages in *The Diary of Anne Frank*, which is a chronicle of an adolescent passage as much as a life arrested, are those in which

Anne compares herself to her older sister Margot. "She's naturally good, kind and clever, perfection itself, but I seem to have enough mischief for the two of us," she writes in one passage, and in another, the eternal question of one child trying to live up to another, "Is it just a coincidence that Father and Mother never scold Margot and always blame me for everything?" ⸱ Trapped in the attic, no friends, no schoolmates, no teachers, Anne can only define herself in terms of her sister. And so they become the good girl and the scamp, the older responsible sister and the younger thoughtless chatterbox. They are archetypes so commonplace as to have become a staple of fiction, perhaps Meg and Amy in *Little Women* or Elinor and Marianne Dashwood in *Sense and Sensibility.* But archetypes are as confining as straitjackets, with as little wiggle room. Says Fredo plaintively to his brother Micharl in *The Godfather II,* "I can handle things. I'm smart." It's just that the place of the smart brother, the one who handles things, has already been filled. And Fredo is left to find something else.

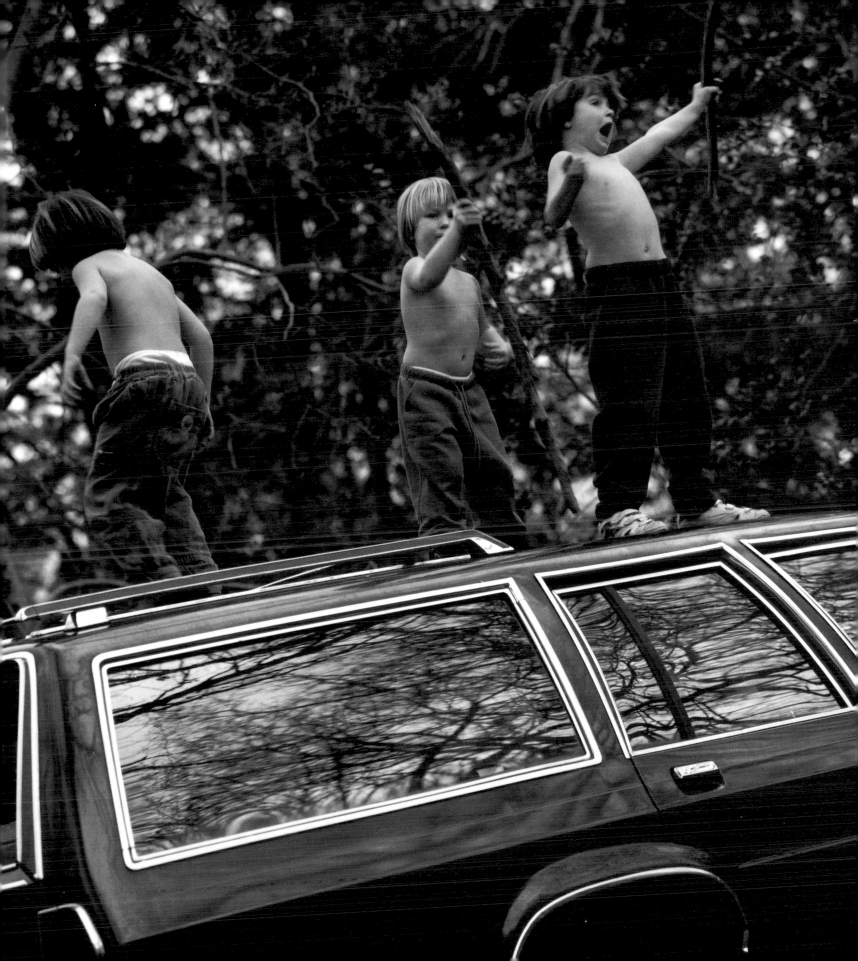

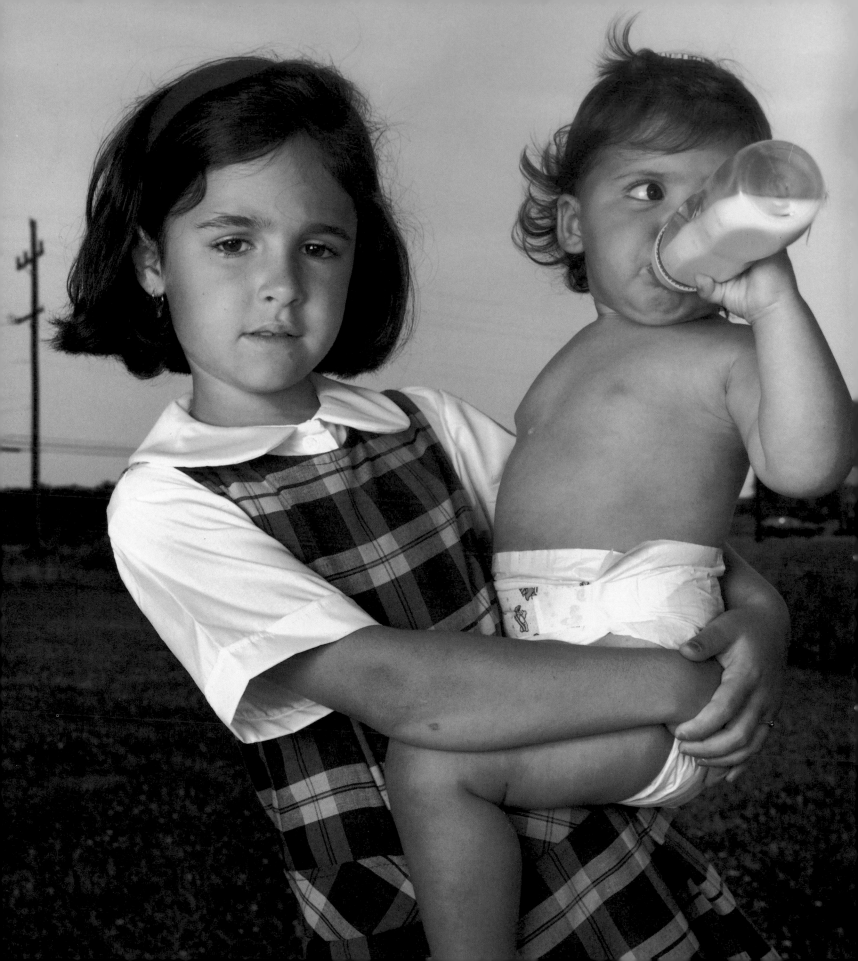

# Supersisters

The young Catherine Quindlen used to make cakes in the kitchen on Saturday afternoons while listening to opera on the radio. Because she was thirty years older than I, I do not know this from observation, but her brothers swear it was so. This is all of a piece with what I know of her myself: how she kept her dishes swaddled in dove-gray chamois bags in the linen closet of her apartment on the East Side of Manhattan; how she changed the lavender sachets in her stocking drawer once a month; how she served salt from a Waterford crystal salt cellar instead of a shaker; how she wrote thank-you notes within a

week of receiving a gift and put her mink coat into storage before the first of May. How she was efficient, intelligent, neat, meticulous, capable, and unfailingly right in everything she did. ❧ Catherine Quindlen was my aunt, but more important, she was the prototype of something I would reluctantly become myself for a time. Not 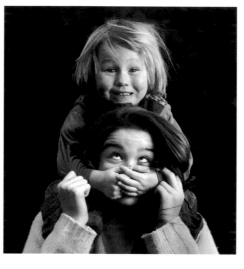 the Manhattan career woman, although she was that, nor merely the eldest girl in a large and fractious Irish Catholic family, although we had that in common, too. No, she was something more than that. She was a Supersister. Perhaps she was one of the last; I suspect that they are something of a dying breed. ❧ I became a Supersister after our mother died, when my siblings ranged in age from 18 to 8. Oh, we all still had a father, but I did the things for them that traditionally a mother did. I covered up, I kept quiet. I got them out of jams. I sometimes lent them money. Some of this is the purview of the eldest child, but it was more than that: I was the only female authority figure left in their life. The Supersister steps in when the parents are incompetent, or ill, or dead, or

aged, or otherwise engaged, when mother has a new baby and one not yet out

of diapers and someone has to tend to the five-year-old. While her brothers

and sisters may have families of their own, the life's work of a

Supersister becomes the well-being of the family

into which she was born. She has been a staple of both literature

and life, the older sister who takes over, who sacrifices and never whines about

it all, who is somehow perfect in her altruism and her essential solitude. She is a

second-string mother of sorts, or at least a matriarch, and that is a kind of

grand and lonely role. ❧ When I was growing up you used to be able to watch

the Supersisters in the making. In the families of six or eight or even twelve,

the eldest girl would often have a baby on her hip or at least a small child by

the hand, walking him to school, learning to mimic the minutia of motherhood:

do you have your homework? What's that spot on your shirt? Remember to be

outside at three. In a portrait of her family my aunt Catherine is wearing the role

as clearly as her dark lipstick and smart suit; three of her brothers look grown,

too, and one of them I know is older than her, but they somehow look callow

beside her adult hauteur. ❧ My father is behind her chair, looking like a cast

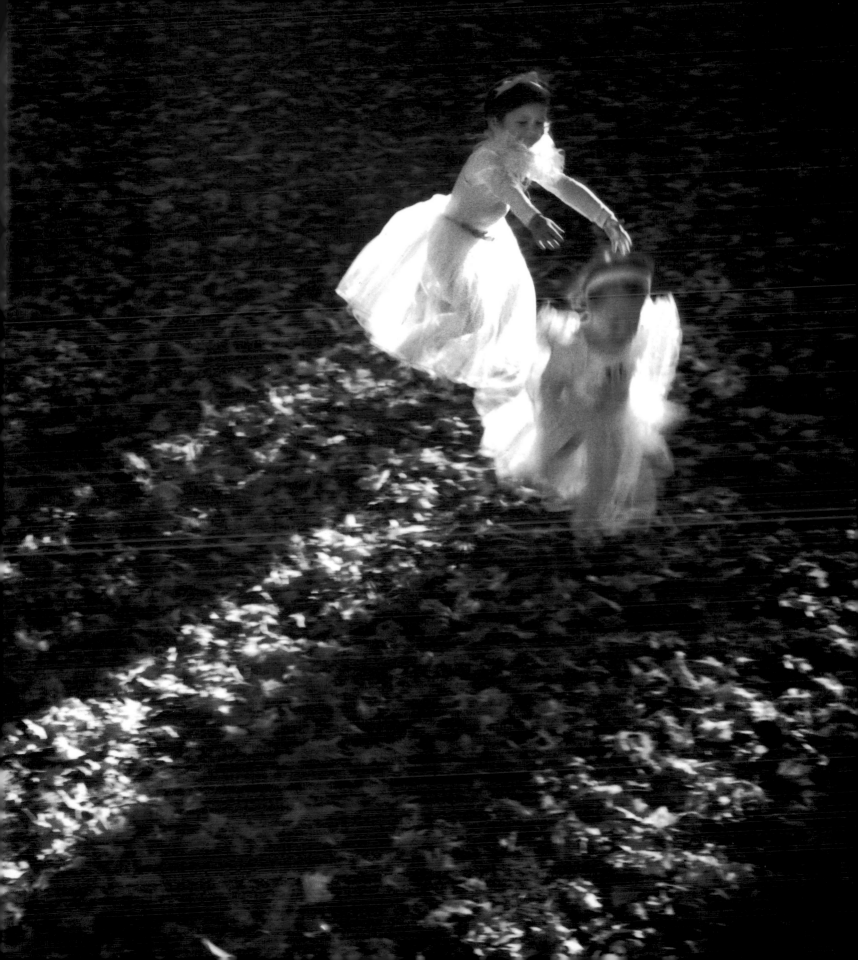

member of *The Little Rascals,* all moon face and freckles, and if life could be breathed into these black and white people he would make a break for it, and she would summon him back, her voice deep, peremptory, a force to be reckoned with. Like many of the Supersisters, her mother was a soft, pretty, somewhat self-indulgent woman who had, naturally, been the youngest in a large family. In the photograph my aunt Catherine looks older, more mature, more serious, than her own mother. § I myself was broken in as a Supersister somewhat early. My sister was eleven years younger than I, and I had wanted her badly after three brothers: I even got to name her, Theresa Bernadette, after my favorite saints, a choice for which, to her credit, she has never reproached me. So it was fair for my mother to assume that I would have some hand in her upbringing. But I was not really cut out to be a Supersister, or perhaps the change in status of women and the gradual unraveling of the American family abetted my natural

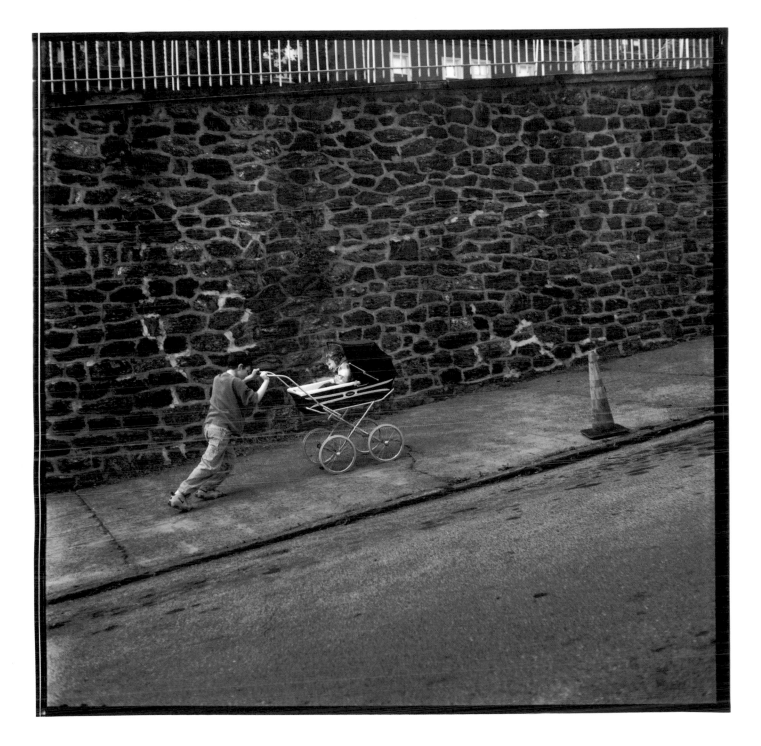

disinclination to do so. For whatever reason, I never played the part in the wholehearted fashion that it had been played in the past. My aunt Catherine never married, nor did the other Supersister in our family, my father's aunt Kit. This may have been simply coincidental, although it never felt that way to me, growing up, when Aunt Catherine swept into the house. (She was barely five feet tall, with feet so tiny they looked like merely the stubs of ankles, but I can assure you that she always swept.) The smell of her perfume, the silk of her powder,

the order inside her handbag, particularly by contrast with the disorder of our households, filled with noisy, dirty, riotous children: it always seemed as though Aunt Catherine had a higher calling. Sometimes, when I see one of those pillows that say "The Princess Is Sleeping" or "It's Not Easy Being Queen," I instantly, reflexively, think of her. ❧ Most of the Supersisters of those years past were assumed to be happy with the corollary role of Superaunt, giving the nicer gifts, always attending communions and graduations, never forgetting a birthday or anniversary. That was the easy part. Later, often, inevitably, they became care-

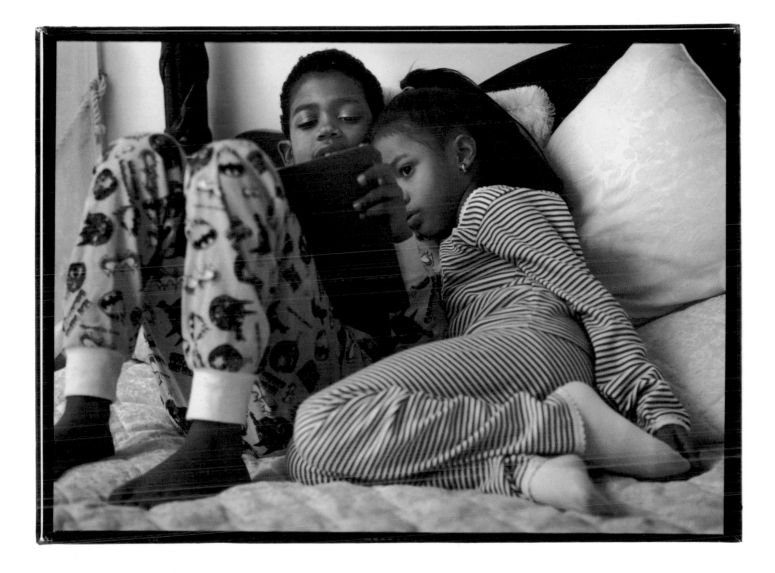

givers. Aunt Kit cared for her aging, ailing parents, my great-grandparents, just

as a generation later, Aunt Catherine did the same with my grandmother, giving

up the apartment in New York City, shoehorning her pretty possessions into

the place in the Philadelphia suburbs. And finally there was me, at age 19, the

Supersister to a clutch of motherless children, putting aside, at least for some

years, the recollection that she was a motherless child herself. ❧ Why not the

boys, you might ask, as I did with fury and stridency, particularly as I packed up

my dorm room and left college to return to the single bed in the room I shared

with my little sister. Are there no brothers expected to take charge, fill in, take

the family to which they were born as their own, their only? Are there no

Superbrothers? Well, my grandfather was one, an older brother who

helped to put the youngest boy through medical school to assure him a stature

and profession that he did not have himself. ❧ But men have long been expected

to take charge and women to take care. Daughters stay home. Sons leave. That's

how it has always been, for as long as I can remember. I hope to change this,

among my own children, to teach them that each sibling has similar, if not identi-

cal responsibilities. But even today, in some households, I see mothers reflexively

using little girls to fetch and carry while the brothers go about their business.

I remember the story of Felix Mendelsson, the great composer, and his sister

Fanny, who when they were younger was said by many to be as considerable

a prodigy as he. But at a certain point their parents gave Fanny the news: for her

brother, three years her junior, music would be a calling, a profession. For her

it must become a hobby. ❧ Perhaps the days of the Supersisters are over, given the

change in the lives of women and the blurring of sex roles. Or perhaps the

change is because of the size of the 21st-century family. Perhaps the Supersister

was partly a function of the need to have more than one woman in charge of

a family with a baby, two toddlers, some kids and a teenager all trying to struggle

through life—not to mention school, puberty, and chicken pox—simultaneously.

Part of the reason I was needed as a Supersister was that I was the eldest of

five, not one of two. And the eldest girl at that. ❧ As a girl who had been raised

always as my father's eldest son, my blood boils to recount that. The fact that,

given that rearing, I was still expected to step into the role of demi-mother

to my siblings speaks to how powerful the cult of Supersister is. The fact that,

given that power, I briefly played the role with little grace or good humor is a

function of both my character and the changing character of family relationships.

Siblings should be siblings, I said, not surrogate

parents for one another, even as I continued to dispense advice,

try to unravel crises, acted for all the world like the superego of my sibling circle.

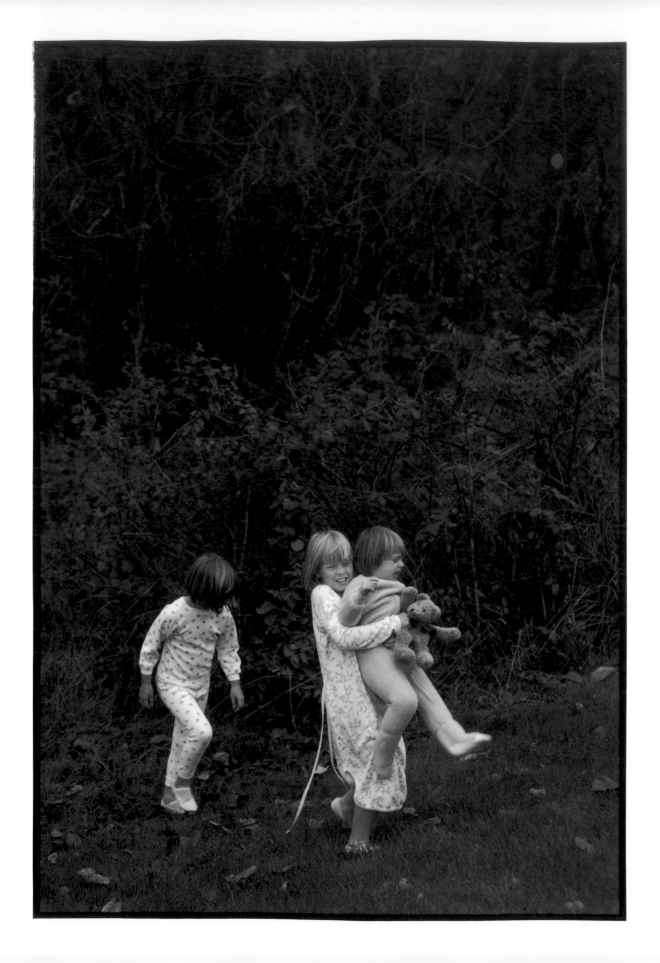

Unlike my aunts, I married, had children of my own. And one day, when I was

obsessing about taking the lead in some family crisis, rearranging my life to

accommodate the difficulties in the life of one of my brothers, my brother Bob

removed the Supersister mantle from my shoulders. "We're adults,"

he said gently. "You don't have to run our lives

anymore." I am not exaggerating when I say that this was one of the nicest,

and most humane, things that anyone has ever done for me. I became a sister

again, without the overweening oversight function. ❧ Yet the truth is that, of all

of Father's great extended family, it was the Supersisters I admired most and

who speak to me most strongly in memory, stay with me longest in my mind

and heart. It was not because of their self-sacrifice, but their stature, and their

dignity. I will never know how they inveighed in their hearts and minds against

the role of selflessness that was, not forced upon them, but expected of them

so matter-of-factly that it was more forceful than any force could be. I only know

that they filled it magnificently, and that our family would have been far, far

less without them.

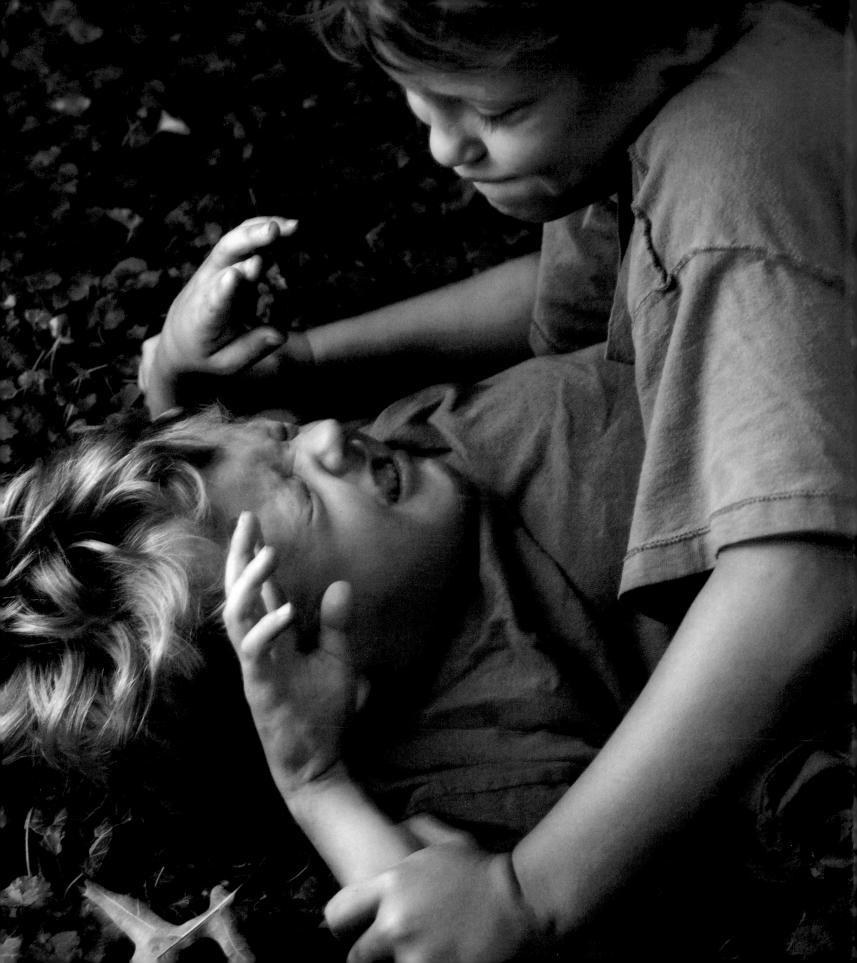

# Irish Twins

My boys are what were once called Irish Twins; that is, I had them less than two years apart and far too close together for most people's comfort. I bought a double stroller and endured the stares of those who were clearly doing the math in their heads. The year after the second was born is a blur to me, all diapers and spilt milk. There may have been no use crying about it, but cry they did. § I did this because I had a deep and enduring belief that two children born less than two years apart

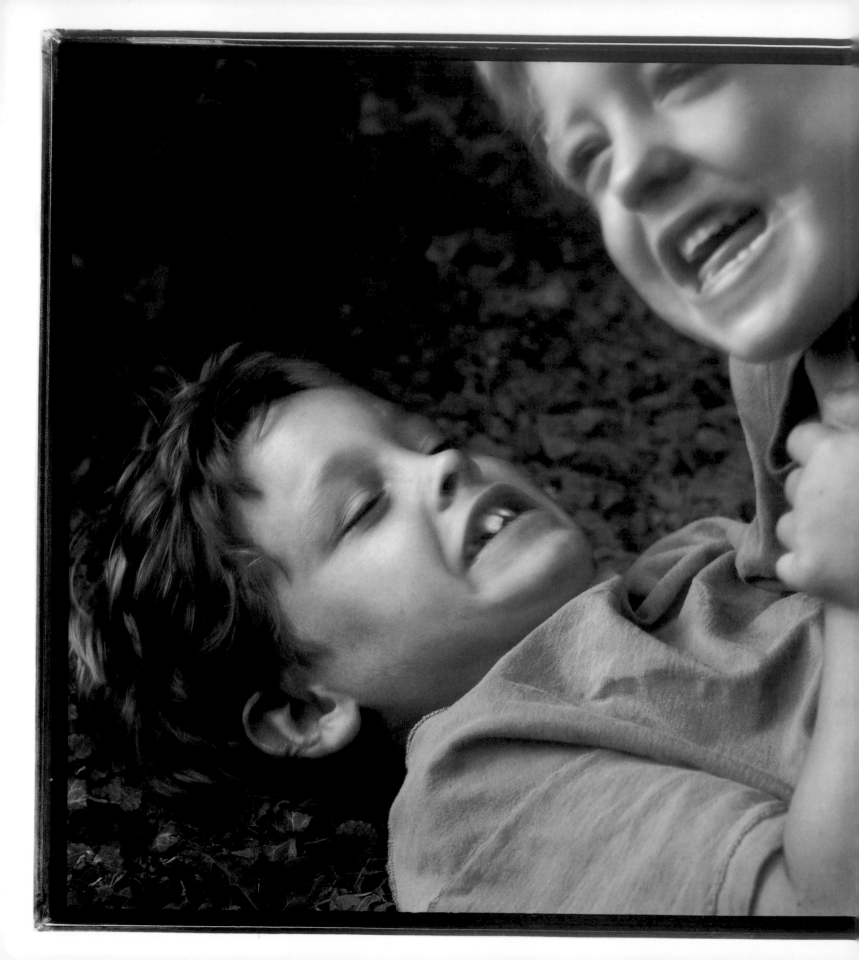

He is my brother.

He is nice.

I like him.

101

would become boon companions and lifelong friends, despite all the evidence

I'd seen to the contrary. But this is indeed what happened. Quin could not

remember life before Christopher, and Christopher had never had a life without

Quin. Christopher used his walker to get as close to Quin as possible and,

when permitted—and he usually was—to grab on to Quin's shirt and be dragged

along in his wake. One of Quin's first words was "Cur," which became "Chrifer,"

which became "Christopher." They shared a room and, at night, little boy conver-

sation that would come to us in fits and starts over the baby monitor. § Once

Christopher was asked to write a paragraph about his best friend. Here is what he

wrote: "My best frend is a boy namd Quin. He likes to play. He is a good drawr.

He is my brother. He is nice. I like him." § It was what we in the trade call

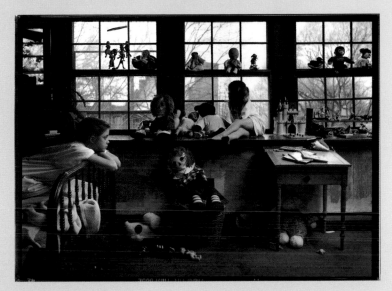

understatement. Not to mention effective. It made my heart rattle in the cage of my chest. ❧ I read in one of my baby books once that it takes a child many, many months before he finally realizes that he is a separate entity from his mother, or, perhaps more important, that his mother is separate from him. Christopher learned that he and I were different people long before he learned that he and Quin were. I had a book on sibling rivalry that I bought and read during my second pregnancy, looking at Quin with drawn brows over its edge. Six months after Christopher was born I gave it away. What I needed was a book on sibling dependency. ❧ Maybe sometimes this happens with siblings of different sexes; I'm not sure. The only times I've seen it it's been with same sex

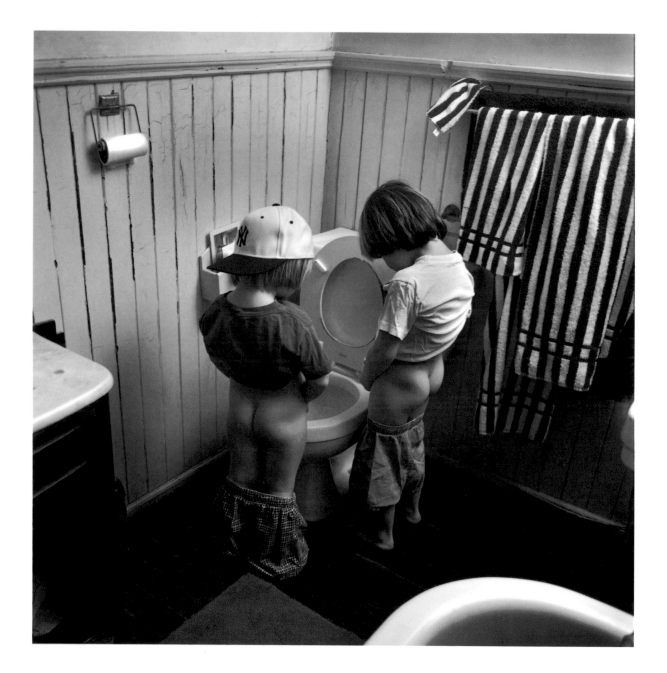

kids; sisters, brothers. Not always then, of course: I knew two sisters once not

18 months apart in age whose mother had been afraid to leave the room when

they were small because she was afraid the elder would do physical damage to

the younger. Whenever I looked at the elder girl I used to think of those Siamese

fighting fish you see, swimming solitary, doing a slow fan dance with those irides-

cent tails in glass bowls in the pet shop. There's never more than one because they

kill each other when they're together. ❧ But that was not what happened with

my sons. They did just what I had hoped. They played together fairly peacefully,

held hands walking down the street once the double stroller had been outgrown.

They could fight, too, and wrestle, try to pin one another down, demand

"Uncle." Siblings like to do that, if they like each other: it is the one safe way

of using your feet and your fists, if you're certain the other person doesn't secretly

have murder in his heart. ❧ They were playmates and confidants and I could

almost see them, in their twenties, on the phone, having a beer in a bar, saying to

one another, "What's up with Mom and Dad?" And sometimes when I saw the two of them, their heads bent together over a game, one dark, one fair, I felt that I had made a perfect world that would continue long after I was gone. § Two things happened to change that. One was that their sister was born, and their magic circle made her feel excluded, which made

them feel bad and made me feel sad. But the second was that, as they grew older, the circle was no longer large enough to contain them, their ambition, their sense of adventure, of wanting to re-create and redefine themselves. § I use that plural pronoun as a kindness, but it is not really accurate. What really happened was that the elder wanted to set sail on the seas of the outside world, to make friends and influence people. It was always clear that he loved and cherished his brother; it was also clear that the bond between them was not sufficient to sustain him, once

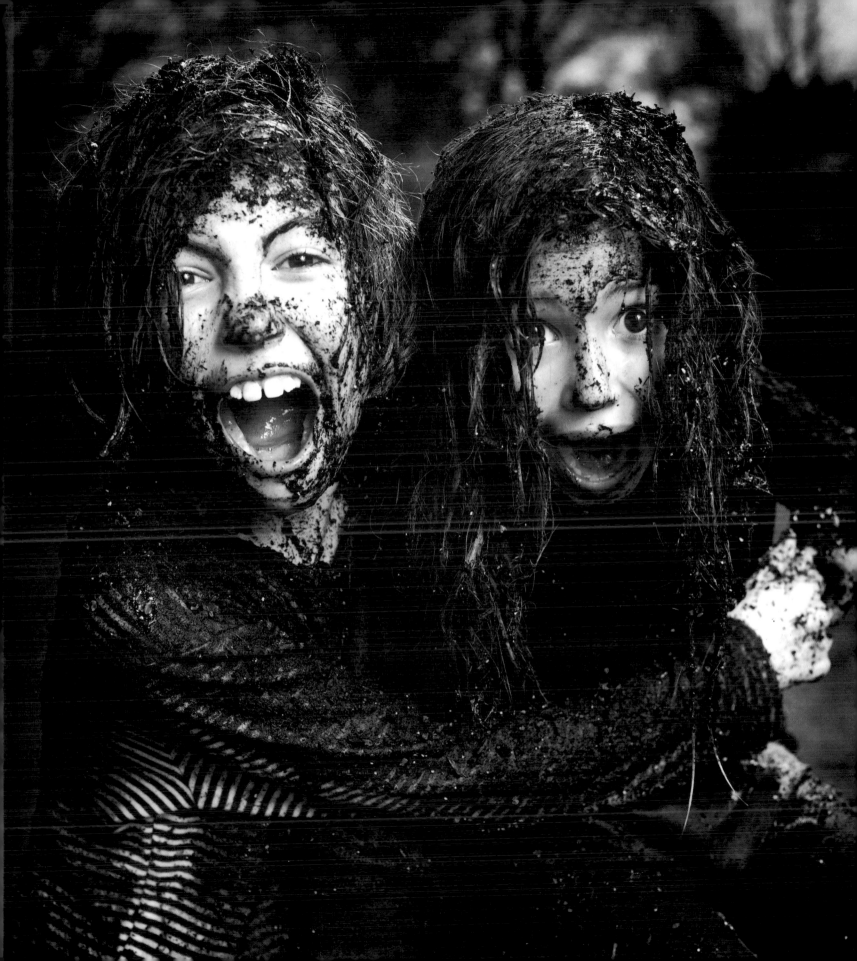

he got older, edgier, more drawn to the tightrope. One day the time came for him

to go off to a different school, a school his younger brother had never visited,

to make friends with boys his younger brother did not know and do things his

younger brother had never done. ❧ When the younger one went back to their

old school that fall, he looked at the end of the day like a hot air balloon that

had lost its flame and its fuel, crumpled and flat and earthbound. This was

particularly noticeable as the elder soared. ❧ I can't tell you how this story ends

yet because I'm in the thick of it now. The younger has moved outside of himself

and his family circle, too; he has begun to inflate again. The elder insists that

he must join him at his new school. Their sister ricochets from one to another.

Sometimes all three of them lie in the hammock stretched between two tall pines

and talk for hours, spinning the fantasy stories they all three like, the eldest

because he is clever, the second because he is creative, the third because the other

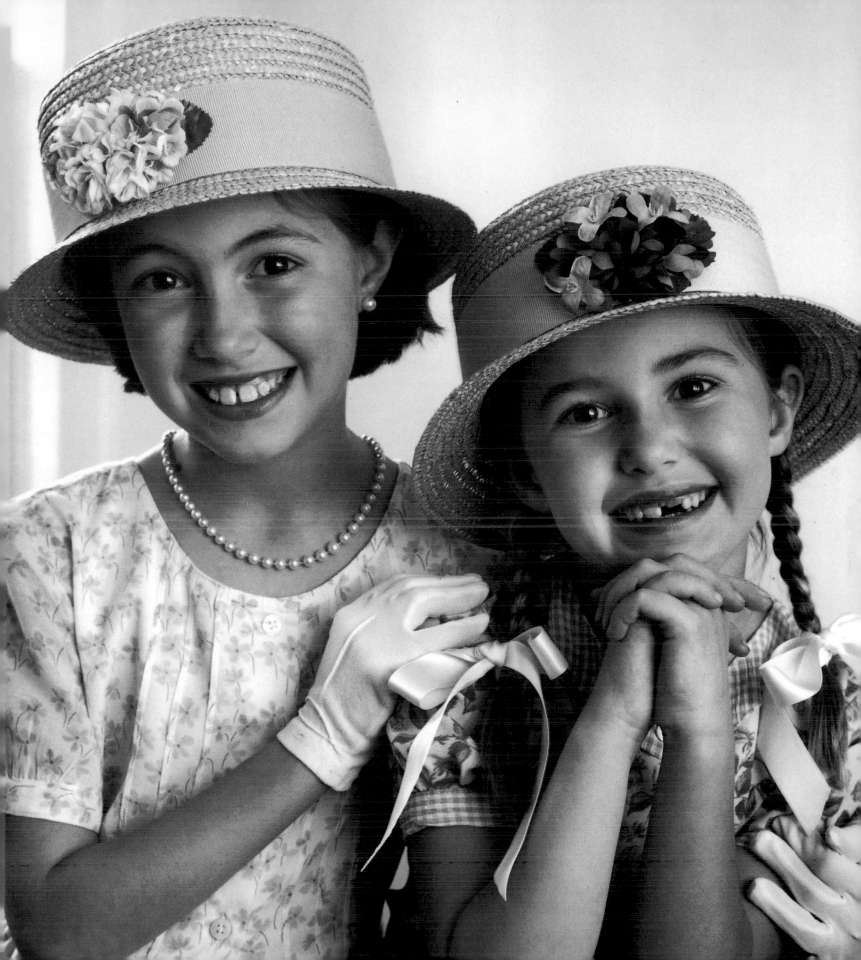

two like to do this and let her in when she does. ❧ They make a charmed circle of their own, the three of them swinging between the trees. I do not belong within it, but I recognize it. I think of climbing into the low-slung seat of my sister's sports car in California at the airport last year, a car I could never buy, given my life now, in a state where I will never live, with a woman I have not seen for a year. It is still so hard for me to think of her as a woman: I still worry about whether she has enough money, or enough furniture, or just enough. I still think of her as a girl, somehow, a baby. ❧ But that is because she is always, first and foremost to me, my sister. There are no preliminaries, as she tears onto the freeway. (Is she careful enough? Does she have tickets? Insurance?) There is none of that small talk that breaks the ice with even our good friends. There is no ice to break. That is what it means to have brothers and sisters, I suppose, in the last analysis: there is no ice to break.

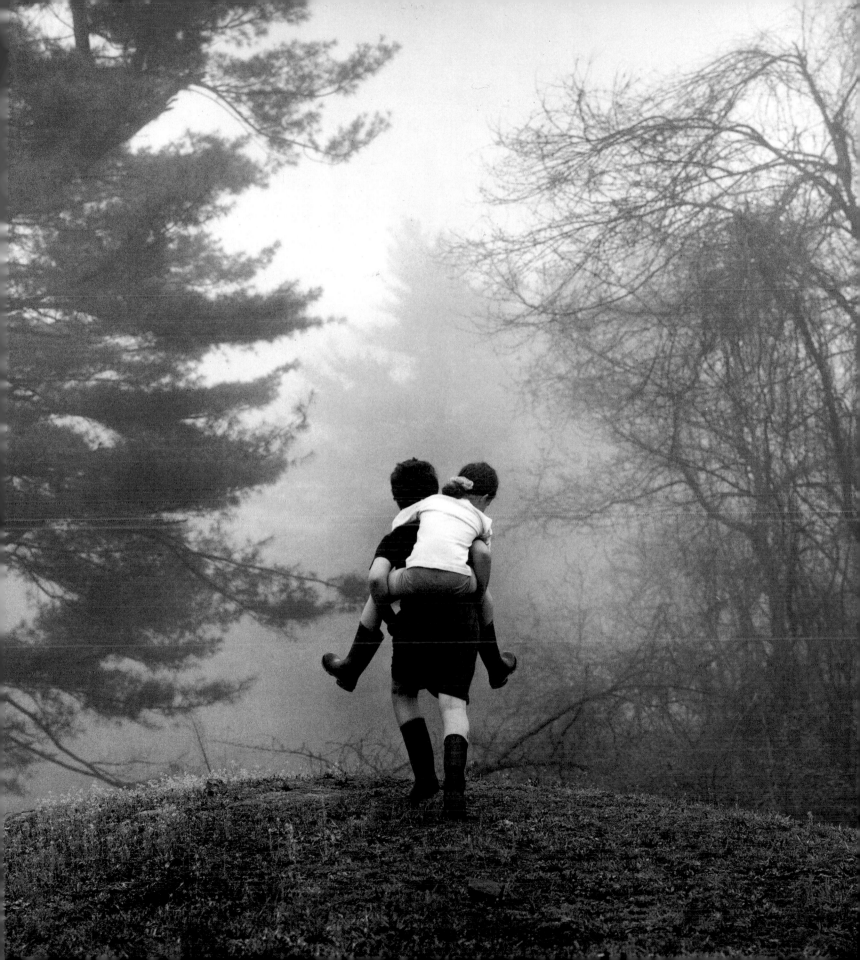

ACKNOWLEDGMENTS

These parents and children generously shared their lives with me and for that I am sincerely grateful.

Edna and Dwight Ashton, *Daquan and Dwight Ashton* • Marianne Tamulevich and Clifford Ayers, *Kimberly and Corbin Ayers* • Tina Kaupe and Bing Bell, *Spencer and Peter Bell* • Lynn and Curt Biehn, *Dierdre and Carl Biehn* • Martha and George Blood, *Ellen, Anne, Freddie, Madeline, and Henry* • Donna and Donnie Brasco, *Danielle, Maria, Erica, and Donald Brasco* • Bridget and Mark Bullen, *Elliot and Alessandra Bullen* • Grace and Greg Burns, *Ashley Burkert and Gregory, Edward, and Oliver Burns* • Jennifer and Bob Celata, *Elizabeth, Katharine, and Carey Celata* • Emily and Jonathan Conant, *Hannah, Alice, and Sam Conant* • Jennifer Preston and Chris Conway, *Grace and Matthew Conway* • Lisa and Joe Corcoran, *Joseph, Kelly, Maggie, Ryan, Matthew, Patrick, and Mary Theresa Corcoran* • Deenah Loeb and Walt Crimm, *Jonas and Emma Crimm* • Louise Moody and Reid Detchon, *Julia, Deborah, and Charlotte Detchon* • Jane and Michael Fragnito, *Luke, Aaron, Robert, and Laura Fragnito* • Ken Geist, *Will and Grace Geist* • Ellen and Tom Giannini, *Christopher Giannini* • Michele and Ed Greenberg, *Jake and Sam Greenberg* • Jennifer and Richard Haaz, *Sam and Chloe Haaz* • Daria Marmaluk-Hajioannou and George Hajioannou, *Kyra and Josef Hajioannou* • Sheila and James Hawes, *Max and Madeline Hawes* • Ellen and Gerry Hurley, *John, Tom, Joe, Bobby, Peter, Jimmy, and Roseanita Hurley* • Denise and Eric Jones, *Philip, Spencer, Bradford, and Caroline Jones* • Sharon and Ken Kind, *Jake, Zac, and Sam Kind* • Margaret Meigs and Paul Laskow, *Sarah, Nick, and Nell Laskow* • Diane and Bruce Luckman, *Sammy and Emma Luckman* • Nancy and Paul Matlack, *Charlotte, Anna, and Nicholas Matlack* • Jill and Paul Mattson, *Jim and Elizabeth Mattson* • Margee and Matt Mille, *Tyler Miller and Jack Mille* • John and Nancy Mulhern, *Patrick Mulhern* • Kelly and Sean Rooney, *Casey, Molly, Haley, and Quinn Rooney* • Carol Wolfe and Peter Samuel, *Zoe, Mia, Ava, Ella, and Colin Samuel* • Colleen Christian and Court Schmidt, *Emma, Claire, and Isabel Schmidt* • Martha and Joseph Shaw, *Maggie, Emily, Erin, and Joseph Shaw* • Karen and Ernie Tracy, *Harrison and Dylan Tracy* • Denise Martell and Jacy Webster, *James and Christian Webster* • Lori and Jon Weinrott, *Sam and Sophie Weinrott* • Atara and Ira Weinstein, *Jessica and Harris Weinstein* • Sachiko and Takahiro Yano, *Ryosuke, Takuya, Ayuka, and Kohei Yano*

Special thanks to Marie Timell, Michael Fragnito, Kevin Monko, Liz Williams, Bud and Joyce Kelsh, Bob Martin, Ruth Harden, Karl Peplau, Wendy Weinstein, Mike Horowitz, Gabe Piser, Cotten Kelsh, and everyone at Kelsh Wilson *design*.